HOW TO UNDERSTAND ART

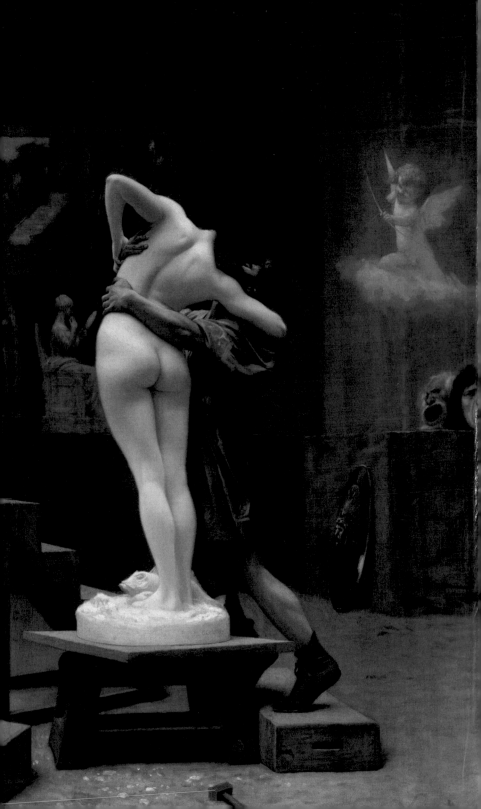

ART ESSENTIALS

HOW TO UNDERSTAND ART

—

JANETTA
REBOLD BENTON

—

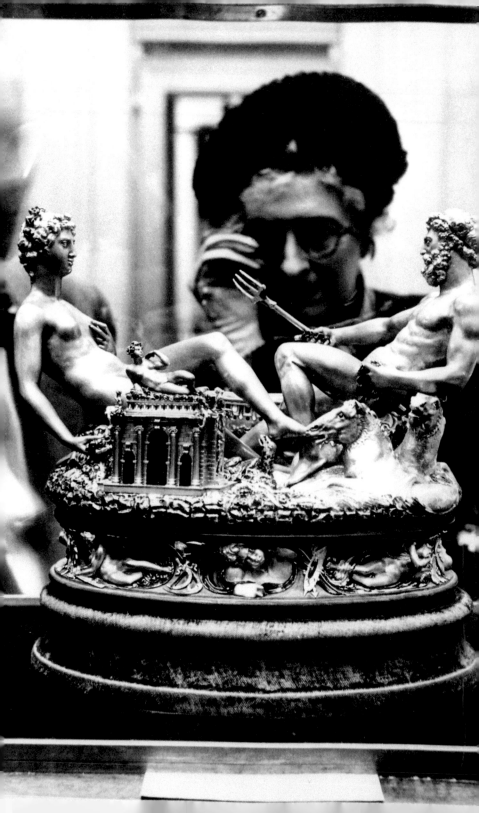

CONTENTS

INTRODUCTION

Pablo Picasso, perhaps the most influential artist of the twentieth century, expressed the idea that art serves to rid us of the dust of daily life. The visual arts make us think and enrich our lives in many ways, bringing us innovative ideas, the pleasure of beauty and a range of emotions – while also puzzling us sometimes. *How to Understand Art* provides a clear and concise overview of the fundamentals shared by all the visual arts, helping the reader to think carefully, inquisitively and, ultimately, critically about art. Honing our visual literacy skills enables us to understand concepts conveyed without words.

The wealth of information and many suggestions about how to approach art offered by this book are intended to maximize your experience by providing a firm basis for simple enjoyment as well as for further investigation. To move beyond 'I don't know much about art, but I know what I like', requires an understanding of why you like it. The goal is to help you do precisely that in the following five chapters.

This book approaches 'How to Look at Art' by posing a series of questions to consider and by introducing some of the great debates in the history of art. Brave attempts are made to define that imprecise yet frequently used term: 'art'. Your skill in 'Experiencing, Analysing and Appreciating Art' increases through comprehension of the basic elements used in all visual arts, including aesthetic principles and styles. An understanding of the 'Materials and Techniques' used by artists makes it possible to assess what can (and cannot) be done in certain media.

Even so, do you find yourself wondering 'But What Does It Mean?' In this section, we look at examples to help demystify the messages in art. Context proves to be key to understanding a specific symbol's meaning. The final chapter explores the life and work of 'Six Special Artists': Leonardo da Vinci, Rembrandt van Rijn, Vincent van Gogh, Frida Kahlo, Pablo Picasso and Andy Warhol. Coming from a range of countries and eras, each occupies a key place in the history of art.

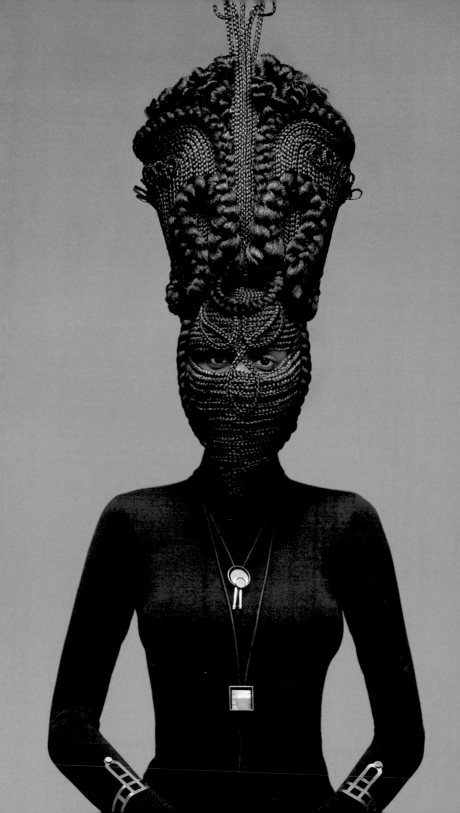

HOW TO LOOK AT ART

-

**Beauty is truth, truth beauty, – That is all
Ye know on earth, and all ye need to know**

-

John Keats
1819

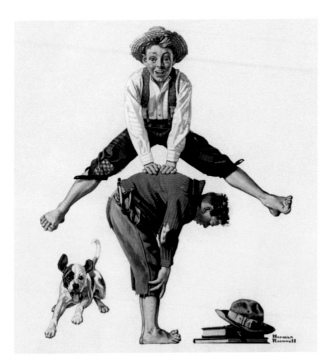

Norman Rockwell
Boys Playing Leapfrog,
published on the cover of
Saturday Evening Post,
28 June 1919
Oil on canvas, dimensions
of the original unknown
Norman Rockwell
Museum, Stockbridge,
MA

**The American Rockwell
created over 4,000
original works during
his career, most for
magazines. Should
Rockwell's status be that
of an illustrator rather
than an artist because
his work was made
for wide distribution
in magazines? How
different is Rockwell's
work from that of the
highly praised sixteenth-
century Netherlandish
artist Pieter Bruegel the
Elder (opposite below)?**

How to Understand Art is concerned with ways to access the visual
arts today. Focusing on painting and sculpture, these pages contain
ideas intended to help you respond to art. The goal is to give you the
tools and awareness necessary to increase your understanding and
appreciation of art, make you more observant and raise your level
of visual literacy.

POINT OF VIEW AND PERSONAL PREFERENCE

Each individual's response to the closely linked questions of 'what is
art?' and 'what is good art?' hinges on personal preferences. What
do *you* think? Do *you* like it? There is much to gain from being
receptive to a wide range of art forms and from making a sincere
effort to be impartial and unbiased in your evaluation. Granted,
it is difficult to avoid applying today's twenty-first-century ideas,
aesthetic tastes and viewpoints to works of art created in earlier
eras, especially by cultures very different from our own. But
try to be flexible and avoid taking positions such as 'I don't like
contemporary art' or 'I'm not interested in metal sculpture.'

It is unlikely this book will change your preferences. Your
proclivities, propensities and predilections may ultimately be much

the same when you reach the last page as when you first picked up the book. However, you will have acquired a frame of reference to understand *why* you do or do not like a work of art, as well as the ability to analyse intelligently and to eloquently explain *why* you prefer almost anything to contemporary metal sculpture.

Do not be intimidated by art museums. Please feel no obligation to praise the so-called 'great masters'. You may remain entirely guilt-free even if you do not like a work of art in the Louvre in Paris or the Hermitage in Saint Petersburg. A conversation overheard by the author at the Boston Museum of Fine Arts, in which a young boy asked his father if they were in a church, demonstrates the 'holier-than-thou' atmosphere often encountered in museums.

TOWARD A DEFINITION OF 'ART'

No precise definition of 'art' exists. Ask Google 'what is art?' and several million results appear. A précis of the many extensive dictionary definitions is that art consists of works of beauty or emotional power created using imagination and skill. Nevertheless, the iconic unabridged Funk & Wagnalls *Standard Dictionary of the English Language*, after a lengthy discourse, finally admits 'art has no synonym'. Indeed, art is not an absolute. No formulas or rules exist to answer the question 'what is art?' Even a quasi-scientific rating system (if 51 per cent answer 'yes' then it must be art) does not exist. Depending on how broad, inclusive or liberal your own personal definition of art is, you may find that some form of art is almost always nearby.

Pieter Bruegel the Elder
Children's Games
(detail), 1560
Oil on wood panel,
116.4 x 160.3 cm
(45⅞ x 63⅛ in.)
Kunsthistorisches
Museum, Vienna

Bruegel the Elder introduced genre subjects to sixteenth-century Netherlandish art. If the distinction between illustration and fine art cannot be based on subject, or where or when a work appears, what can it be based on?

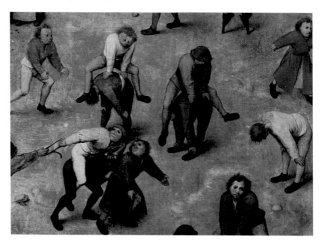

What qualifies as 'fine art'? As 'art'? As 'craft'? Is there even a reason to make such distinctions? Many people call, or would like to call, themselves artists. They are free to do so for, unlike labelling oneself an engineer, doctor or lawyer, no educational requirements, examinations or laws control this designation. The American Pop artist Andy Warhol said, 'An artist is someone who produces things that people don't need to have.' He defined art as 'what you can get away with'.

-

Should we conclude that the greater the antiquity of a work, the more likely are its chances of being proclaimed fine art?

-

If the clever social criticism found in the paintings and prints of the eighteenth-century English artist William Hogarth and the nineteenth-century political cartoons of the French artist Honoré Daumier is art, what about today's cartoons? If today's cartoons are derided as being beneath the level of fine art, but those of earlier eras are not, should we conclude that the greater the antiquity of a work, the more likely are its chances of being proclaimed fine art?

Should we label things such as 'readymades', constructed or compiled from existing items, art? Pablo Picasso's *Bull's Head* (1942; opposite) consists of the handlebars and seat of a bicycle that he welded together. Certainly, imagination and insight were involved, characteristics normally associated with art, for Picasso saw something in the ordinary parts of a bicycle that others had not and made a clever new use of old objects with his novel combination. Given today's emphasis on preserving the resources of our environment, I dub this 'recycle bicycle art'. Picasso employed this notion of reusing ordinary items in other works, including his *Baboon and Young* (1951; Museum of Modern Art, New York), in which the head of the mother baboon is made from two of his son Claude's toy cars, cast in bronze.

-

Love is an equally imprecise term and the answer depends on the person you ask

-

Perhaps asking, 'what is art?' is akin to asking, 'what is love?', for love is an equally imprecise term and the answer depends on the person you ask. There are different kinds of love – that felt by

Pablo Picasso
Bull's Head, 1942
Leather bicycle seat and metal handlebars welded together, 33.5 x 43.5 x 19 cm (13⅜ x 17⅛ x 7½ in.)
Musée Picasso, Paris

Picasso, Spanish by birth but active in France, one of the most famous and creative artists of the twentieth century, shows us that art may be discovered in the most ordinary things with his ingenious reuse of bicycle parts. **But is his** *Bull's Head* **in a museum because it is art, because it is clever, or because it is by Picasso?**

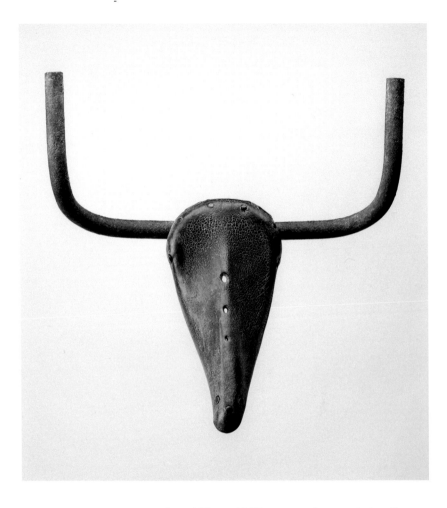

a parent for a child or a child for a parent, for example, is unlike romantic passion or a patriotic love for one's country. Degrees of emotion vary from slight affection to intense and all-consuming love for which people have sacrificed their lives. There are differences in duration from fleeting infatuation to life-long love. So then, is the work of art in question something you enjoy for a brief moment or one that provokes thoughts that leave you profoundly moved? Will you forget it in an hour, or would you want to see it when you wake up each morning?

The answer to the question 'what is art?' has tended gradually to become ever more comprehensive and inclusive. This is due in part to the introduction of new techniques and materials. Many people now consider photography to be equal to painting as an

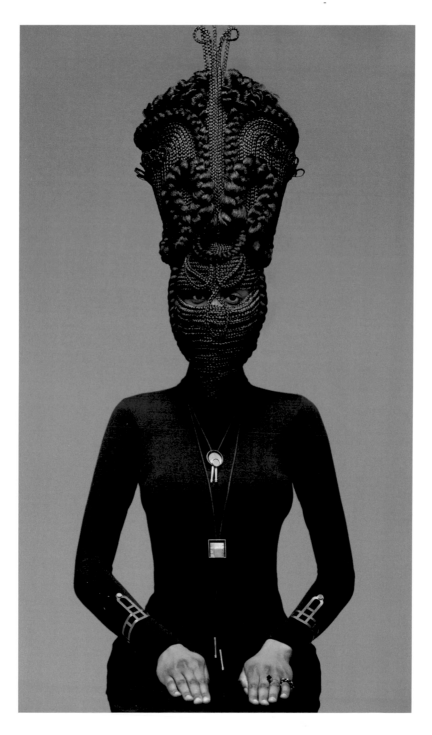

Delphine Diallo
Hybrid 8, 2011
Chromogenic print from
an edition of 8, 114.3 x
76.2 cm (45 x 30 in.)
Headpiece by
Joanne Petit-Frère
Private collection

**The Senegalese-French
photographer Diallo
and the American
hair artist Petit-Frère
explore the artistic
potential of an unusual
medium. Sculptures
made of elaborately
braided human hair
may be seen as wearable
renewable art.**

art form. The artistic status of computer graphics, newer still, has
yet to be established. Our increased willingness to embrace a wide
variety of types of visual expression has come to include some forms
previously marginalized as 'primitive art' or 'outsider art', or even
scorned, such as so-called 'graffiti art', which formerly would have
been considered an oxymoron.

Creativity and novelty also join forces in photographs taken by
Senegalese-French Delphine Diallo. Her portraits focus on what
she calls the 'Divine Feminine', the inner beauty and energy of
women. In *Hybrid 8* (2011; opposite), the sitter is both masked and
unmasked, hidden behind hair that reveals her ethnic culture.
Diallo collaborates with American Joanne Petit-Frère to create
this soft sculpture by using hair as an artistic medium, employing
traditional braiding techniques to form shapes usually created in
conventional sculpture materials. Petit-Frère says her major source
of inspiration comes from nature, and the shapes she constructs
convey an organic quality.

Art and music may effectively convey many of the same emotions

There are many links between the various arts, and artists often
work in more than one creative discipline. The aesthetic concepts
found in critical analyses of painting and sculpture and presented in
this book also apply to other art forms – especially music, dance and
theatre. The descriptive vocabularies used in these several disciplines
are often similar. For example, adjectives such as loud, soft, harsh
or gentle can describe colours as well as sounds. Paintings in which
the artist applies the brushstrokes to the canvas in rapid succession
are akin to staccato music performed with each note sharply distinct
from the next. Art and music may effectively convey many of the
same emotions.

WHY IS ART CREATED?

People have produced art in all areas of the globe, in all eras of
history, in all societies: the need to create is universal. But art
is created for different reasons. When looking at a work of art,
consider its function and the artist's intention. It may immortalize
the person portrayed or enhance a patron's prestige. Perhaps
it tells a story or records an important historical event. It might
demonstrate a young artist's mastery of skills in a masterpiece.

Maybe the painting preserves the natural beauty of a landscape or floral arrangement. The impetus for a work of art could be any one or several of these possibilities – or something entirely different. The following examples suggest the great range of purposes art has served.

The ancient Egyptian *Seated Scribe* (below) comes from a tomb in Saqqara, and thus was never intended for the eyes of a living person. Several similar sculptures of Egyptian scribes exist; their purpose was to serve the pharaoh in the next world as a living scribe had in life. Art humanely replaces a living person of flesh and bone with an inanimate one of paint and stone.

The intent behind certain recent works of art may be far more difficult to decipher. In 2002 the secretive British artist known as Banksy stencilled the image of a little girl releasing the string on a heart-shaped balloon as the wind blows it away, beside the words 'There is Always Hope,' on Waterloo Bridge in London. The

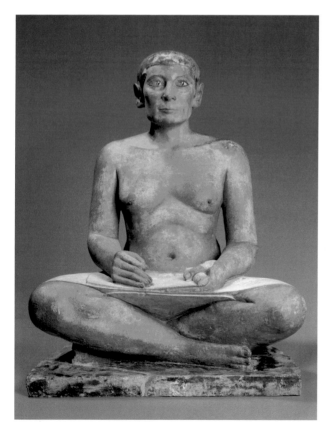

Unknown artist
Seated Scribe, from Saqqara, Egypt, c.2600–2350 BCE, 4th or 5th dynasty
Painted limestone, eyes inlaid with rock crystal in copper, 53.7 x 44 x 35 cm (21⅛ x 17⅜ x 13¾ in.)
Musée du Louvre, Paris

Pharaohs expected their servants, represented by statues, reliefs or paintings, to accompany them to the afterlife and continue their service eternally. These ideal employees, never late to work, were always alert and ready to serve.

Banksy
Girl with Balloon, 2006
Shredded just after
its sale at a Sotheby's
auction in 2018, retitled
Love Is in the Bin
Aerosol paint, acrylic
paint, canvas, wood and
shredding mechanism,
101 x 78 x 18 cm
(40 x 30¾ x 7⅛ in.)
Staatsgalerie, Stuttgart

**Banksy, the anonymous
British street/graffiti
artist whose identity
remains disputed, creates
clever stencilled images
that often contain
satirical messages about
contemporary social and
political issues.**

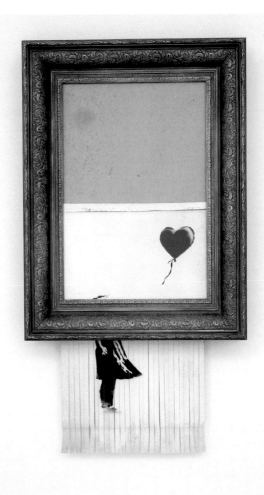

balloon presumably represents love and the hope that accompanies
childhood innocence, now floating out of reach. A canvas of this
image sold at a 2018 Sotheby's auction in London for £1,042,000.
As the auctioneer's gavel fell, finalizing the rapid-fire bidding, *Girl
with Balloon* self-destructed when a shredder built into the frame
activated – to the amazement of everyone watching! The shredder
left the image half destroyed (above). Banksy then retitled the
work *Love Is in the Bin*. What was Banksy's intention? Was it to tell
art collectors at Sotheby's that, like innocence, the value of art is
fleeting? Did Banksy create a form of 'performance art'? A publicity

stunt? Known for his public interventions, Banksy won worldwide attention with this one, actually increasing the value of the shredded work – and perhaps of his other works.

Sometimes long-held assumptions about the purpose of a work of art require re-evaluation. Did the early Netherlandish artist Jan van Eyck intend the *Arnolfini Portrait* (opposite) painted in 1434 to document the wedding vows of Giovanni Arnolfini and Jeanne Cenami, as was long thought? The writing on the wall above the mirror translates, 'Jan van Eyck was here', the artist thus stating he was a witness. He further proves to the viewer that he was present by including himself in the reflection in the mirror that shows the couple from the back. However, the recent discovery that Cenami was Arnolfini's second wife and their marriage did not occur until 1447 (although the artist died in 1441) casts the identity of both figures into question. Art historians now debate whether the purpose of this painting is a wedding or betrothal document; a memorial portrait of a recently deceased first wife, who may have died in childbirth; or something else, waiting to be revealed by the discovery of a fifteenth-century document.

Jan van Eyck
Arnolfini Portrait, 1434
Oil on oak panel,
82.2 x 60 cm
(32⅜ x 23⅝ in.)
National Gallery, London

The Netherlandish artist Jan van Eyck's models for this portrait were long believed to be Giovanni Arnolfini and Jeanne Cenami. However, discovery that Arnolfini and Cenami did not marry until after the artist's death puts not only the names of the models but also the purpose of this painting into question.

ART AS A RECORD OF HISTORY

As visual records, works of art sometimes provide revealing information about the culture that created them in terms of beliefs, degree of prosperity, politics, religion, customs, costumes and more. Thus Jan van Eyck portrayed not only the interior of an upper-middle-class home of the fifteenth century in the Netherlands, but also a way of life. To our eyes today, the woman's abdomen suggests that, if the painting does indeed depict the exchanging of betrothal or wedding vows, the event occurred none too soon. However, her protruding abdomen was a contemporary fashion, a look carefully cultivated by those who did not have this contour naturally. The cut of the garment and a small padded sack placed under the garment, as well as the wearer's posture, called the 'pregnant stance', created the desired appearance. Also fashionable at the time was her horned hairstyle, achieved by wrapping the hair around wire cones affixed to her temples.

Not only an image, but also the circumstances of its creation, provide historical information

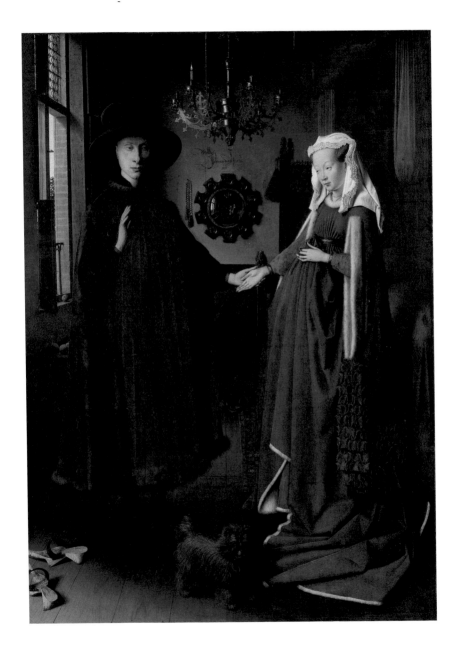

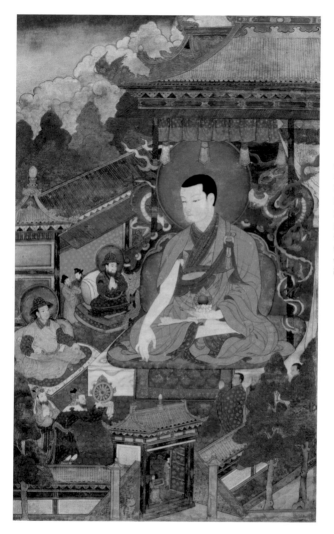

Unknown artist
Initiation of Kublai Khan and offering Tibet to Phakpa (Phagpa) in 1264, Tibet, c.16th–17th century
Pigment on cloth,
64.5 x 41.6 cm
(25⅜ x 16⅜ in.)
Rubin Museum of Art,
New York

Art as historical narrative exists the world over. Here the Tibetan artist documents a transfer of power and authority, providing irrefutable evidence that, as the saying goes, 'a picture is worth a thousand words' in any language.

Art may document important events in religious and political history, sometimes both together. The painting above records the enthroned guru Phakpa (or Phagpa, 1235–80), leader of the Sakya school of Tibetan Buddhism, endorsing the power of the Mongol leader Kublai Khan (1215–94) in 1264. In return, Kublai Khan gave Phakpa power over portions of Tibet. To indicate his greater importance in this Tibetan painting, the artist portrayed Phakpa much larger than Kublai Khan, who presses his palms together to show respect. Kublai Khan would found the Yuan dynasty of China in 1271.

Not only an image, but also the circumstances of its creation, provide historical information. If the artist made the work to fulfil a commission, consider the relationship between the artist, the patron and the finished work. How much of what you see indicates the artist's creative ideas – as opposed to the patron's requirements? The individual or organization commissioning a work of art probably had an important role in determining its appearance.

Prior to the nineteenth century in the west, artists worked almost exclusively on commission

Duccio di Buoninsegna
Maestà, main front panel of altarpiece, 1308–11
Egg tempera and gold on wood panel,
2.13 x 3.96 m (7 x 13 ft)
Museo dell'Opera Metropolitana del Duomo, Siena

Information about the life of Duccio, the leading Sienese artist of the early fourteenth century, may help us understand his work. In addition to the contract for his *Maestà* and documents about other commissions he received, the city archives preserve records of his many wine bills and fines for misconduct!

The notion of artists painting or sculpting subjects that appeal to them personally, and then selling the artwork later to customers via an agent, gallery or exhibition – what may be termed 'paint now, sell later' – became common only in the nineteenth century. Prior to this, artists worked almost exclusively on commission. The patron probably stipulated the subject, perhaps the imagery used to convey its meaning, the size of the work and the quantity of certain materials used, especially if these were costly pigments or metals. The agreement between patron and artist might indicate the extent to which the artist was free to do as the artist pleased while creating the work of art, including the possibility of hiring assistants and accepting other jobs concurrently.

A rare surviving early contract for a painting between the authorities of Siena Cathedral and the Italian artist Duccio is that

for his *Maestà* altarpiece (1308–11; previous page). This contract, held in the State Archives of Siena, stipulates that Duccio must not hire assistants, must do all the work himself and must not undertake other paintings until he completed the *Maestà*, which he did in 1311.

ART AND FUNCTIONALITY

If a work of art serves a practical function, is it less 'art' than if it has no utilitarian purpose and is purely aesthetic? The issue of art versus craft may require some extremely subtle distinctions. For example, does a lavishly embroidered textile used as a wall hanging deserve higher artistic credibility than an equally embellished textile worn as a garment? If an artist paints the same image on a canvas as on a bowl intended for mass-production and domestic use, is the bowl beneath the canvas in the hierarchy of art's social registry?

The Italian Mannerist Benvenuto Cellini sculpted splendid allegorical figures of Tellus and Neptune (1540–43; below) of gold and enamel for the French king François I. Does the fact that they are essentially a salt and pepper holder diminish their status? Attitudes to this question have changed over the years. Cellini lived

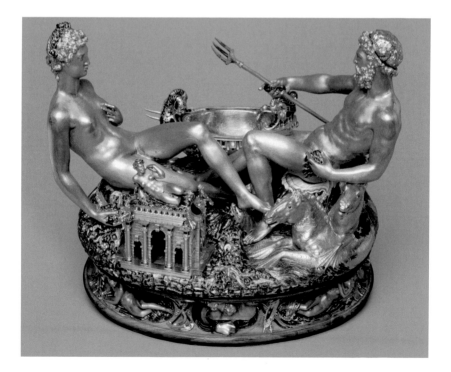

during the sixteenth century, long before Europeans defined the concept of fine art in the eighteenth century. The fine arts, denoting high aesthetic quality, were differentiated from the applied arts, which referred to the creation and decoration of functional objects however elaborate. Some claim this distinction serves to maintain high artistic standards, whereas others argue it is exclusionary elitism.

Are museum curators to answer this question? The items exhibited in art museums have become increasingly varied and inclusive. The Metropolitan Museum of Art in New York displays armour and weapons, some designed by famous artists, alongside the traditional fine arts. Should armour, therefore, be considered a fine art? The Musée d'Orsay in Paris exhibits household furniture among the French Impressionist paintings and sculptures. Taking this idea to an extreme, Arthur Young's Bell-47D1 helicopter, made in 1945, hangs from the ceiling in the Museum of Modern Art in New York. How do you react to the exhibition called 'Art of the Motorcycle', shown at the Guggenheim Museum in New York in 1998 and then in Chicago, Bilbao and Las Vegas? Did the engineers who designed these motorcycles for mass-production ever entertain the idea that their work was destined for display in prestigious international art museums? If the person who created the work did not consider it art, can it nevertheless legitimately be proclaimed to be art by curators and critics at a later date?

Artists trained in the guild system tended to be anonymous

As is often the case, the past offers insight both to understanding the present and to predicting the future. Certain ancient Greek ceramics carry the names of both the painter and the potter and give them equal recognition. For example, both Euphronios and Euxitheos signed the red-figure calyx-krater on which the *Death of Sarpedon* was depicted c.515 BCE (Museo Nazionale Archeologico Cerite, Cerveteri). On some vases, the signature indicates that painter and potter were the same person, suggesting neither of these jobs was considered more prestigious than the other.

Throughout the Middle Ages in western Europe, the person who painted a picture on a wood panel, like the person who constructed the panel, trained in the guild system and within its anonymity is almost invariably unknown by name today. There was little distinction between the people we now label as either artists or artisans because the same person might create not only paintings

Benvenuto Cellini
Tellus and Neptune, salt and pepper holder, 1540–43
Gold, enamel, ebony and ivory, 26.3 x 28.5 x 21.5 cm (10⅜ x 11¼ x 8½ in.)
Kunsthistorisches Museum, Vienna

Cellini, sculptor to the most important patrons in France and Italy, praised his own skill as an artist (and a lover) in his autobiography. This extraordinary condiment container, with its complex iconography (salt comes from Neptune's sea and pepper from Tellus's earth), puts fine art into fine dining.

and sculptures but also design furniture, tableware, book covers, armour, clothing and tapestry – virtually everything.

This attitude changed during the Renaissance. Now believing that artistic inspiration was divine in origin, society regarded artists as favoured by God and thus different from other people. Nevertheless, the German Renaissance artist Hans Holbein the Younger, in addition to being Henry VIII of England's portraitist, designed book bindings, royal seals, ceremonial weapons, jewelry and table silver for the king, much as Benvenuto Cellini did for François I of France.

Today discussion of the distinction between artisans and artists, as well as between crafts and fine arts, continues. If high-quality unique works produced by craftspeople are both beautiful and functional, and works produced by artists are purely aesthetic, should we accord higher status to objects because they serve no function? This would support Warhol's definition of an artist as 'someone who produces things that people don't need to have'.

TECHNICAL EXECUTION AS A CRITERION?

Is a carefully and precisely made painting or sculpture, with everything finished neatly and exactly, better art than if it is crudely made? That is, should we assess artistic value only on the idea, or also on the technical execution of that idea?

The rise of art academies gradually supplanted the guilds

In cultures that made no distinction between artists and artisans, people who worked as painters and sculptors were likely to have been educated by family members and/or through a long guild apprenticeship, much like anyone skilled in a craft or trade. Such was the situation in medieval Europe. A student was to master the specific technical skills taught; development of personal artistic style was not included in the curriculum. The student trained to become a master, ultimately accomplishing this by demonstrating a high level of proficiency through the creation of a 'masterpiece', and thus qualifying to teach others. Consequently, how well an artist executed a work technically and how thoroughly the necessary skills were mastered were of great importance.

The rise of art academies gradually supplanted this system of education. In Italy the Carracci family of painters, including the

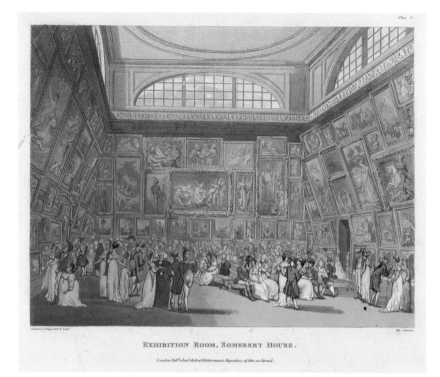

EXHIBITION ROOM, SOMERSET HOUSE.

London. Pub.ᵈ June.ᵗ ... at R.Ackermann's Repository of Arts ... Strand.

Thomas Rowlandson and Augustus Charles Pugin
Exhibition Room, Somerset House, 1808
Aquatint and etching, sheet 24.7 x 29 cm (9¾ x 11½ in.)
The Metropolitan Museum of Art, New York

Joshua Reynolds, the Royal Academy of Art in London's first president, expounded theories and rules of art similar to those of Charles Lebrun, director of the Académie Royale de Peinture et de Sculpture in Paris. Reynolds's fifteen *Discourses* consist of inhibiting rules welcomed by his contemporaries.

brothers Annibale and Agostino with their cousin Ludovico, founded an art academy in Bologna in 1582, thereby taking art education away from the guilds. France established the Académie Royale de Peinture et de Sculpture (Royal Academy of Painting and Sculpture) in Paris in 1648. Charles Lebrun became director in 1663 and set up a rigid system of education in both theory and practice. Gradually artists came under the control of the Académie because Lebrun was in charge of all the art projects of King Louis XIV. Codifying the rules, standardizing the arts and dictating the subjects and style of French art of his day, Lebrun's actions were generally stifling to originality. England created a similar system with the founding of the Royal Academy of Arts in London in 1768 (above).

A fundamental change occurred in the second half of the nineteenth century in France. Through its annual juried exhibitions in Paris, known as Salons, the Académie had long controlled which artists' work the public saw, thereby both moulding public taste and determining the professional success or failure of individual artists. In 1863 the Salon jury rejected over 4,000 paintings, producing such an uproar from the rejected painters and their supporters

that Emperor Napoleon III set up a second Salon for the rejected paintings, known as the Salon des Refusés (Exhibition of Rejects). This signalled the beginning of the downfall of the academic approach, for the Salon jury no longer exerted such powerful control over French art.

Painters and sculptors, liberated from the obligation to please the Salon juries, were free to turn away from traditional subjects, such as religion, mythology, history or politics, preferring to derive their inspiration from daily life and nature. Interests turned to new painting methods utilizing colour and optical studies to investigate principles of vision and light. Attitudes to the technical aspects of painting changed as the smooth surfaces, careful draftsmanship and detailed representation long favoured by the Academy diminished in importance.

Today, technical execution is ever less vital to artists than in earlier centuries. With this diminished emphasis on technique comes the expected: some recent works of art, including certain examples presently exhibited in major museums, are already crumbling, flaking, chipping, cracking or otherwise in need of conservation and/or restoration.

Unknown artist
Ti Watching a Hippopotamus Hunt, c.2500–2400 BCE, 4th dynasty
Painted limestone wall relief, height c.114.3 cm (45 in.)
Tomb of Ti, Saqqara, Egypt

Ancient Egyptian paintings depict what the mind knows is there rather than what the eyes actually see. Favouring clarity of meaning, each item is depicted from its most characteristic point of view. Thus all fish, hippopotami and boats are shown from the side.

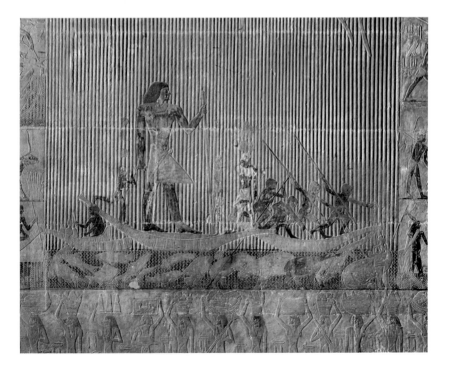

TRADITION VERSUS INNOVATION

Is it possible to create art according to rules and theories, as
Charles Lebrun and Joshua Reynolds believed? Today, general
opinion holds that the creation of art involves imagination, intuition,
inspiration, even genius. We admire originality and novelty, regarded
favourably as progress. Yet even as artists seek to create something
unique, an accepted component of an artist's education continues
to be the study of the 'old masters'. Students benefit by examining
the past, using it to better equip themselves to create something
new: first imitate, next create and ultimately innovate.

At certain times in the past, the attitude was largely the
reverse. Consider two ancient Egyptian wall paintings from
tombs: *Ti Watching a Hippopotamus Hunt*, dated c.2500–2400
BCE (opposite) and *Nebamun Hunting in the Marshes*, c.1350 BCE
(below). A millennium later, the same non-naturalistic conventions
of representation persist. Both artists render the head from the
side, yet the eye from the front; the shoulders from the front, yet
the legs from the side; and the relative size of the figures indicates
their position in society rather than their position in space. The
only significant exception to the ancient Egyptian reverence for

Unknown artist
*Nebamun Hunting in the
Marshes*, from the tomb-
chapel of Nebamun,
Thebes, Egypt,
c.1350 BCE, 18th dynasty
Painted plaster wall,
98 x 115 cm
(38⅝ x 45⅜ in.)
British Museum, London

**Naturalism combines
comfortably with a
degree of decorative
abstraction on the walls
of Egyptian tombs.
The hieroglyphic writing
emphasizes the flat
picture plane.**

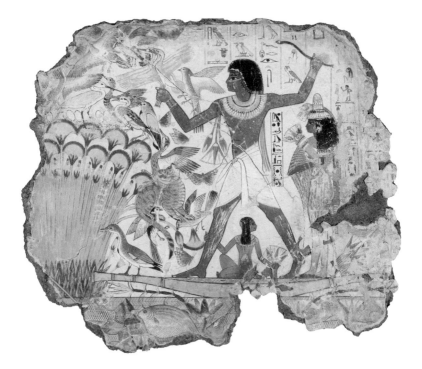

reiteration and tradition, which applied to much more than their art, was during the eighteenth dynasty under Pharaoh Amenhotep IV (also known as Akhenaten, died c.1336/1334 BCE), and the changes he introduced largely disappeared after his reign.

In contrast to the ancient Egyptians, who established their ideals and maintained them with minimal change for millennia, the ancient Greeks and Romans repeatedly modified their paradigm of aesthetic perfection. They developed intellectual theories that combined science and art, utilizing mathematical ratios to achieve ideal proportions, be it for the human body or a building.

-

Interest in the human figure has continued unabated throughout the history of art

-

The *Spear Bearer* (*Doryphoros*), known in a Roman marble copy of the bronze statue created by the Greek sculptor Polyclitus (Polykleitos; c.450–440 BCE), displays the ideal proportions for a man during the classical period as eight heads tall (Museo Archeologico Nazionale, Naples). Later, during the Hellenistic era, the ideal was slenderer at nine heads tall, as demonstrated by the *Scraper* (*Apoxyomenos*), a Roman marble copy of a bronze original by the Greek sculptor Lysippos (c.330 BCE; Museo Pio Clementino, Vatican City, Rome). The late first-century BCE Roman architect and author Vitruvius continued the use of mathematics to determine ideal male proportions, making the head one-tenth the height of the body. The Italian Renaissance artist Leonardo da Vinci illustrated Vitruvius's description in his famous drawing of a man according to the Vitruvian canon of proportions (c.1490; Gallerie dell'Accademia, Venice).

Interest in the human figure has continued unabated throughout the history of art. Recent representations are notably varied. One extreme appears in the unnaturally slender, spindly figures created by the Swiss sculptor Alberto Giacometti, such as *Woman of Venice III* (1956; opposite left). In contrast, rotund figures, seemingly inflated rather than emaciated, characterize the work of the Colombian sculptor Fernando Botero, seen in his *Standing Woman* (1993; opposite right). With regard to the constantly changing anatomical types that have interested artists and the range of physiques –male and female – portrayed, virtually all have been proclaimed the paragon at one time or another. Lucky is the person who is born at the right moment in history to match the then-current ideal.

Opposite left:
Alberto Giacometti
Woman of Venice III, 1956
Bronze, 118.5 x
17.8 x 35.1 cm
(46⅝ x 7 x 13⅞ in.)
Collection Fondation
Alberto & Annette
Giacometti, Paris

The Swiss Giacometti, an important twentieth-century sculptor, had a unique view of the human body. This woman is hardly more than a shadow, as Giacometti turns exaggeratedly thin anatomy into an artistic aesthetic.

Opposite right:
Fernando Botero
Standing Woman, 1993
Bronze, 73 x
30.5 x 26.5 cm
(28¾ x 12 x 10½ in.)
Edition six of six
Private collection

The Colombian Botero held a more generous view of this woman's anatomy. His obese figures with swelling contours further expand a body type favoured by the seventeenth-century Flemish Baroque painter Peter Paul Rubens (see pages 42–3).

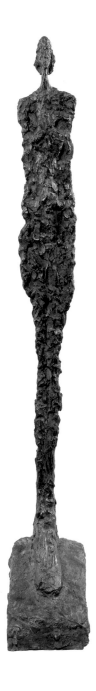

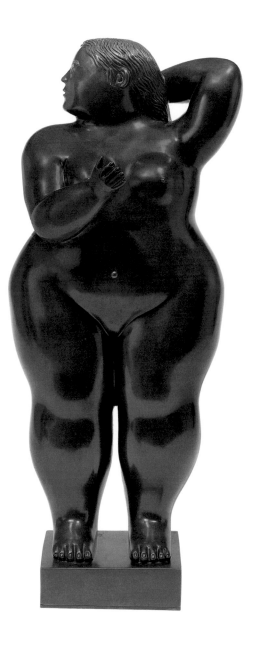

That failing, we may each take comfort in knowing we were in the past, or will be in the future, deemed anatomical perfection and the envy of all.

BEAUTY, EMOTION AND MESSAGE IN ART

Should a work of art have beauty? Must it be attractive? Even pretty? Consider *The Sisters* (1869; below), a double portrait by the French Impressionist Berthe Morisot of lovely young ladies who are fashionably dressed and ruffled, carefully groomed, and shown to be at ease in their comfortable plush surroundings. Such pastel pleasantries are typical of Morisot and of Impressionism in general, for as Morisot's fellow French Impressionist Renoir, born only one month later, said, 'A picture ought to be a lovable thing, joyous and pretty, yes, pretty. There are enough boring things in this world without our making more.' The Canadian poet Bliss Carman expressed a similar sentiment in *The Making of Personality* (1908), when he noted, 'The business of art is to afford joyance . . . what a shame it is the great gifts of expression should ever be wasted on heinous and joyless subjects.' The French Expressionist painter, Henri Matisse, in his *Notes d'un peintre* (Notes of a Painter; 1908), wrote, 'What I dream of is an art of balance, of purity and serenity, devoid of troubling or depressing subject matter, an art which could be . . . a soothing, calming influence on the mind, something like a good armchair that provides relaxation from physical fatigue.'

Berthe Morisot
The Sisters, 1869
Oil on canvas,
52.1 x 81.3 cm
(20½ x 32 in.)
National Gallery of Art,
Washington, DC

Morisot produced inviting landscapes and, especially, portraits of members of her family – her favourite subject was her only child Julie. In pursuing a successful career as a painter, Morisot did not follow the lifestyle expected by her prominent family.

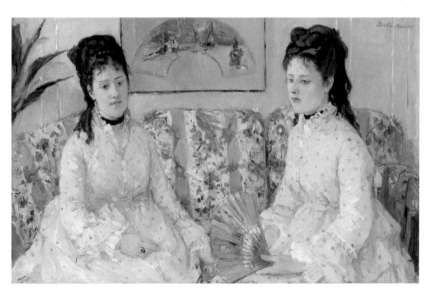

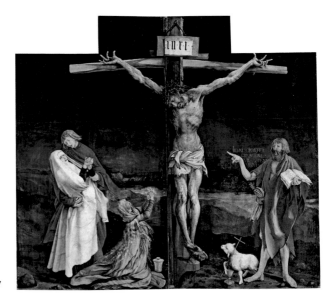

Matthias Grünewald
Isenheim Altarpiece,
1512–16
Oil on wood, central
panel, 2.69 x 3.07 m
(9 x 10 ft)
Unterlinden Museum,
Colmar

**Grünewald, a German
painter, strove to evoke
a strong emotional
response in the viewer.
Even the producers of
today's horror movies
rarely create an image as
repugnant as this of a
tortured, crucified, nearly
nude man.**

The overtly grotesque and intentionally horrifying image encourages the viewer to suffer with Christ

If you agree with Renoir's point of view, that a work of art should be 'joyous and pretty', how do you react to the German Renaissance painter Matthias Grünewald's *Isenheim Altarpiece* (1512–16; above)? Neither 'joyous' nor 'pretty' will be among the words used to describe this distorted, contorted figure of Christ crucified, his flesh grey with decay and eaten by worms. The overtly grotesque and intentionally horrifying image encourages the viewer to suffer with Christ. Few, if any, people look at the *Isenheim Altarpiece* and remain unmoved, even if they are unfamiliar with the religious story portrayed here. Does our visceral reaction make it any more 'art'? Or less?

Should a work of art induce an emotional response?

Grünewald's painting raises another question: should a work of art convey an emotion to the viewer or actually induce an emotional response in the viewer? Is it any better or more successful if it

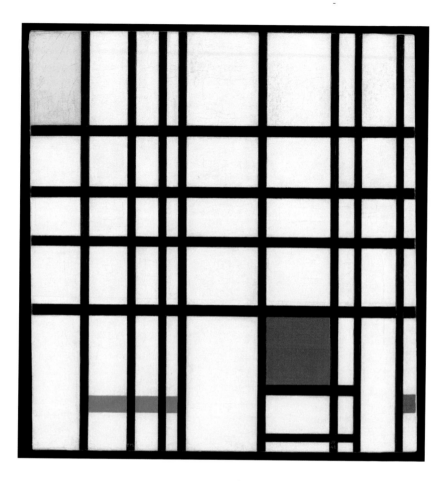

does? Compare the *Isenheim Altarpiece* to the Dutch artist Piet Mondrian's *Composition with Yellow, Blue and Red* (1937–42; above), with its perfect balance of primary colours, black and white, and straight lines. Do you feel anything? Little emotion is involved in this intellectual arrangement that is more cerebral than visceral.

Connected with the possibility of a work of art conveying emotion is its ability to convey a message. Is it desirable for a work of art to tell the viewer something? If so, must the artist do all the work, providing straightforward, unambiguous visual information? Alternatively, does the viewer get more out of the experience by participating in the process? Artists have produced intentionally unfinished works that encourage, if not obligate, the viewer to collaborate with the artist and complete the work in their own mind. The French sculptor Auguste Rodin's *Thought* (c.1895; opposite),

Piet Mondrian
Composition with Yellow, Blue and Red, 1937–42
Oil on canvas,
72.7 x 69.2 cm
(28⅝ x 27¼ in.)
Tate Collection, UK

The Dutch painter Mondrian gradually moved from a figurative painting style to one of intellectual severity. Ultimately nature was simplified into a pure style of carefully composed basic colours and rectilinear shapes.

32

Auguste Rodin
Thought, c.1895
Marble, 74.2 x
43.5 x 46.1 cm
(29¼ x 17¼ x 18¼ in.)
Musée d'Orsay, Paris

The French Impressionist
Rodin's 'unfinished'
sculpture of Camille
Claudel encourages the
curious viewer to wonder
what the uncarved stone
contains – and conceals.

makes use of this idea by carving only a portion of the portrait of his collaborator and lover Camille Claudel into a finished form, implying that within the crude stone (the mind) may be found beautiful thoughts.

Abstract art employs this idea to a much greater extent. Each individual will see different things in the Armenian-American Arshile Gorky's puzzling painting with its equally enigmatic title, *The Liver Is the Cock's Comb* (1944; opposite). The artwork stimulates each of us to create our own personal message. For more on abstract art, see pages 122–5.

KEY IDEAS

Towards a definition of 'art':
 Continually elusive yet increasingly inclusive
Why is art created?
 Several of the many different purposes of art
 Art as a record of history
 Documentary evidence
Art and functionality:
 Fine art and utilitarian craft
 Role of museums in determining what is 'art'
Technical execution as a criterion for evaluation:
 Guilds, academies and the Salon
Tradition versus innovation:
 The human figure
Beauty, emotion and message in art:
 'Unfinished' works of art as a conscious choice

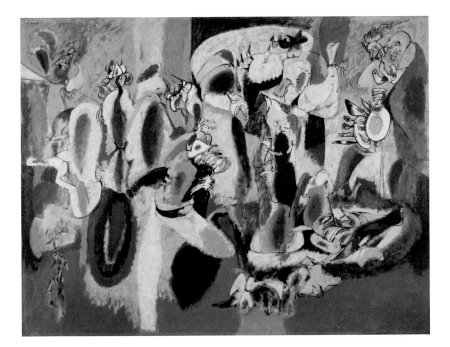

Arshile Gorky
*The Liver Is the
Cock's Comb*, 1944
Oil on canvas,
186 x 250 cm
(73¼ x 98⅜ in.)
Albright-Knox Art
Gallery, Buffalo

**Born in Armenia, Gorky
received his artistic
training in the United
States and developed
a style of complete
abstraction. Because the
meaning is not specified
and the forms are not
made identifiable by
the artist, an abstract
painting offers a different
and private experience
for each viewer.**

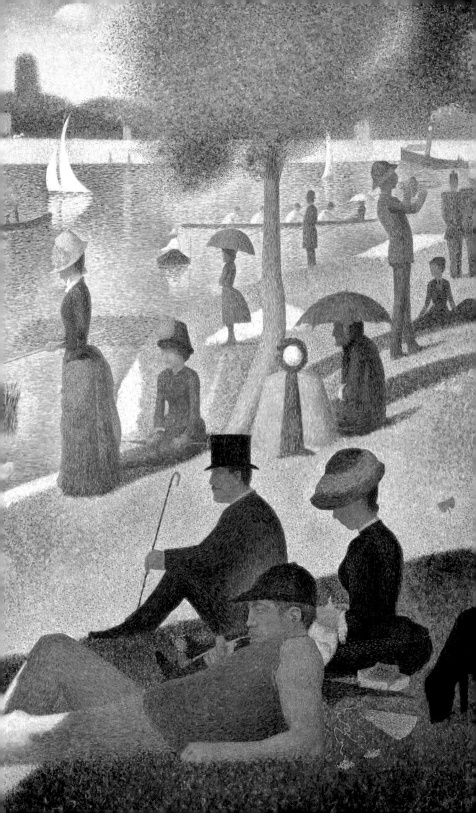

EXPERIENCING, ANALYSING AND APPRECIATING ART

-

Whatever the style, content or medium, art making is a visual language which speaks through color, value, line, rhythm, texture and the illusion of space

-

Kay WalkingStick
2020

This chapter offers ideas to keep in mind that will maximize your experience, help you analyse and appreciate art and even create art yourself. The basic elements used in all visual arts are: colour, line, texture, light, space, composition and emotion. Although this book focuses on painting and sculpture, many of the concepts related to these elements apply also to other forms of the visual arts including the decorative arts, prints, photography, digital art and even architecture. There are no rules that control an artist's use of these basic elements. Although art has benefitted from science, art is not a science.

COLOUR

Paint pigments derive from natural and artificial sources. Natural pigments include chemical elements such as carbon, gold, silver and tin; minerals such as metallic salts; coloured earth such as ochres; precious stones such as ultramarine blue from lapis lazuli; and extracts from plants and insects. Artificial pigments result from combining chemical elements or applying acid to metal as well as the decomposition of salts and synthetic substances. Good pigments should neither fade nor discolour over time.

The primary colours of paint pigment are yellow, blue and red, from which it is possible to mix all other colours except black and white. The secondary colours are green, purple and orange, made by mixing two primary colours. Complementary colours are those

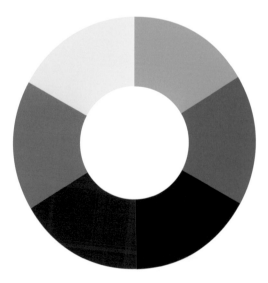

Colour wheel
Illustration of
colour relationships

Sir Isaac Newton
developed the first colour
wheel while studying
the refraction of light
through a prism. A
rotating colour wheel
will appear white as the
colours blend together
in the viewer's mind.
This simple colour
wheel clarifies the
relationship between
primary, secondary and
complementary colours.

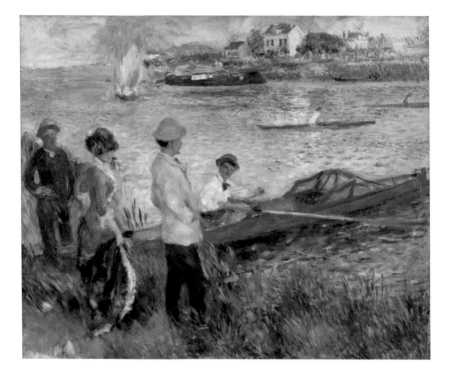

Pierre-Auguste Renoir
Oarsmen at Chatou, 1879
Oil on canvas, 81.2 ×
100.2 cm (32 × 39½ in.)
National Gallery of Art,
Washington, DC

**The French Impressionist
Renoir exploited the
visually striking effect
achievable through
the juxtaposition of
the complementary
colours orange and blue.
Impressionist painters
used brighter, lighter
colours than in previous
styles. This included
working on a white canvas
rather than a brown
ground as had long been
customary.**

across from one another on a colour wheel (opposite): thus yellow
and purple are complementary, as are green and red, as well as blue
and orange. Each pair consists of one primary and the secondary
colour made by mixing the other two primaries. Thus they have no
colour in common. Because they offer maximum contrast, when
placed side by side both colours appear brighter and more intense.

This visual phenomenon was used to advantage by the French
Impressionists. In Pierre-Auguste Renoir's *Oarsmen at Chatou*
(1879; above), for example, the orange boat is the complement of
the blue water, and the woman's orange jacket appears more vivid
because Renoir juxtaposed it with her blue skirt.

The use of complementary colours also appears in Op Art, an
abbreviation of Optical Art, enhancing the vibrating, even dazzling,
visual illusions. This abstract, geometric style of precise painting
gained popularity in the 1960s. Among the best examples are
the paintings by Hungarian-French Victor Vasarely (1906–97),
called the father of Op Art. The striking impact achievable through
complementary colours helps create eye-catching posters,
packaging and advertising designs.

**Colours may be described as warm or cool
and, correspondingly, advancing or receding**

Colour has its own nomenclature. Hue refers to the actual
colour, such as yellow or purple. Intensity or saturation refers to
how vivid a colour is, the highest level being pure colour. To lower
the intensity, add the complement of the colour. Value refers to
how light or dark a colour is. To raise the value, add white, thereby
creating a tint or pastel; to lower the value, add black, thereby
creating a shade. Colours may be described as warm or cool and,
correspondingly, advancing or receding. Warm colours such as red
and orange appear to advance forward in a painting, whereas cool
colours such as green and blue appear to recede into depth.

Colour blindness usually manifests as difficulty in distinguishing
red and green, but may include additional colours that also appear
brownish-grey. Approximately 8 per cent of men have a red–green
deficiency; a much smaller percentage of women are affected. The
Englishman John Dalton, himself colour blind, published the first
scientific study of colour blindness in 1798. Today, special glasses
help the majority of colour-blind people distinguish reds and greens
by using lenses that selectively filter the wavelengths of light that
enable us to see colours.

**Line can direct the viewer's eyes
within a painting**

LINE

Even the simplest line may be highly effective in conveying
meaning, implying motion or stasis, agitation or calm, happiness
or sadness. Line can direct the viewer's eyes within a painting.
A series of closely spaced lines may model a shape, transforming,
for example, a circle into what appears to be a three-dimensional
sphere. When the lines are parallel to one another the technique is
called hatching, and when the lines cross each other, cross-hatching.
The Italian Early Renaissance painter Sandro Botticelli's flowing
lines are so beautiful that we forgive the anatomical anomalies they
create on the figure of Venus in his *Birth of Venus* (1485–6; Galleria
degli Uffizi, Florence).

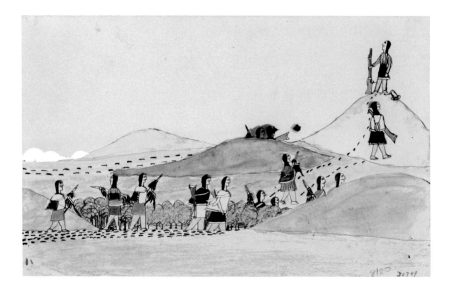

Koba (Wild Horse)
*On the Lookout for
Game*, from Fort Marion,
Florida, 1875–8
Pencil, ink and
watercolour on paper,
12.7 x 20.3 cm
(5 x 8 in.)
National Museum of
American History,
Smithsonian Institution,
Washington, DC

This work by a Kiowa
warrior made on
ledger paper relates to
paintings on hides by
the indigenous peoples
of North America.
Men painted historical
events, women painted
abstract designs.

Line is especially effective in creating informative visual narratives. Notable examples are the many drawings made by indigenous people living in the Great Plains known as ledger drawings because the paper on which they are drawn came from old ledger books. These drawings have an unusual origin: the federal government imprisoned men from various Native American tribes at Fort Marion in Saint Augustine, Florida. Twenty-six of the prisoners, encouraged by their jailers, created these drawings between 1875 and 1878, documenting the lives of Native Americans. The ledger drawings are factual and specific, often depicting battles fought on horseback. The example illustrated above by Koba (Wild Horse) shows Kiowa people hunting. The lines of dashes indicate where they walked. The carefully observed details, recorded in expressively drawn outlines and then coloured, add to their documentary and artistic value.

Poussin, through the use of implied line, organizes his five figures within the shape of a triangle

Implied lines may subtly suggest shapes. Thus the French Baroque painter Nicolas Poussin's *Holy Family on the Steps* (1648; following page), through the use of implied line, organizes his five figures within the shape of a triangle, a stable geometric form

frequently used by artists as a compositional device. The rectangular shape behind Jesus' head serves to frame and thereby emphasize him.

Rubens, in contrast to Poussin, favoured colour over line

Line versus Colour

Each of us seems to have a natural preference for either line or colour and, if given the choice of a pencil with which to draw or a brush with which to paint, some of us will prefer the former and others the latter. Poussin, favouring line over colour, drew his composition carefully before applying paint. He selected his colours intellectually, clothing the most important figures – Mary and Elizabeth – in the primary colours of red, blue and yellow. Around them are the secondary colours: Joseph wears purple, and orange fruits and green leaves complete the circle.

In contrast, the Flemish Baroque painter Peter Paul Rubens favoured colour over line. He essentially painted the same subject as Poussin in the *Holy Family with Saints Elizabeth and John the Baptist* (c.1615; opposite), working directly with rich colour. The juxtaposition of contrasting colours skilfully manipulated

Nicolas Poussin
Holy Family on the Steps, 1648
Oil on canvas,
73.3 x 105.8 cm
(28⅞ x 41⅝ in.)
Cleveland Museum
of Art, Cleveland

Although the French artist Poussin painted during the Baroque period, he rejected its emotionalism in favour of an analytical, intellectual style indebted to the antique. Poussin gives precedence to line and geometric composition.

enhances the trademark sumptuous, even sensual, quality of paintings by Rubens, creating convincing textures of soft flesh and flowing fabric.

These two different and opposed approaches to painting created a significant conflict during the seventeenth century. Those people who favoured line, referred to as Poussinistes, claimed line was superior because it appealed to an educated mind. Those who favoured colour, referred to as Rubénistes, maintained colour was superior because it was truer to nature and appealed to everyone. What may appear to be a minor dispute involving nothing more than individual tastes and personal aesthetic preferences, actually had a far broader impact. If line pleased the mind, while colour pleased the eye, was the purpose of painting to educate and elevate our intellect or to provide visual pleasure? These issues raised fundamental questions about the use of art – and the audience for whom art was intended.

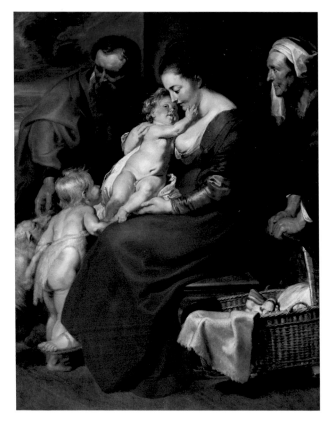

Peter Paul Rubens
Holy Family with Saints Elizabeth and John the Baptist, c.1615
Oil on panel,
114.5 x 91.5 cm
(45⅛ x 36 in.)
Art Institute of Chicago, Chicago

Rubens was one of the most successful artists of the Flemish Baroque era, both artistically and financially. The fleshiness of his characteristically full-bodied figures corresponds with the lush colours and fluid brushwork.

TEXTURE

When describing a work of art, texture does not refer to how it would *actually* feel, if you were to touch it (which you must not, no matter how tempting), but instead to how it *appears* it would feel – the implied texture. Some artists give special emphasis to textural illusions, such as the Spanish Baroque painter Diego Velázquez. His painting of an *An Old Woman Cooking Eggs* (1618; below) displays his skill by convincingly depicting a variety of different substances: the polished metal and terracotta vessels, the liquid in which the eggs cook, the glass flask and the melon the boy carries, the straw basket that hangs above, fabrics thick and thin and the skin of the young boy contrasted with that of the old woman.

-

Seurat eliminated the possibility of creating illusions of texture with his innovative painting method

-

Diego Velázquez
An Old Woman Cooking Eggs, 1618
Oil on canvas,
100.5 x 119.5 cm
(39⅝ x 47 in.)
Scottish National Gallery,
Edinburgh

Early in his career Velázquez was one of the first Spanish painters to produce genre scenes such as this. The various textures are depicted with such specificity as to make them appear tangible. Later Velázquez became a popular painter in the Spanish court.

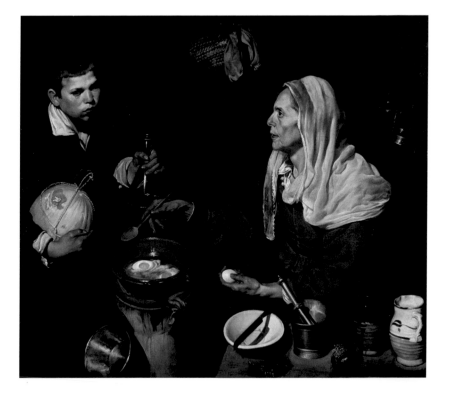

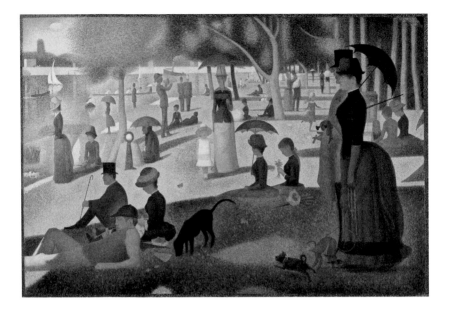

Georges Seurat
*A Sunday on La Grande
Jatte – 1884*, 1884–6
Oil on canvas,
207.5 x 308.1 cm
(81¾ x 121¼ in.)
Art Institute of Chicago,
Chicago

**The French Post-
Impressionist Seurat
incorporated scientific
advances in the
understanding of colour
in his paintings. In his
technique, descriptively
called divisionism or
pointillism, the countless
dots of pure colour blend
in the viewer's eyes.
Seurat's focus is not on
texture but on vision and
colour theory.**

Other painters show no interest in distinguishing between
different textures. This observation does not imply a value
judgement for, like the artist's other tools, use of texture is optional
rather than obligatory. In his painting *A Sunday on La Grande
Jatte – 1884* (1884–6; above), the French Post-Impressionist
Georges Seurat eliminated the possibility of creating illusions of
texture with his innovative painting method. Because each hue is
divided into its component colours, this is known as divisionism, or,
alternatively, because those colours are applied in little points or
dots, as pointillism. If a small section of this painting were isolated
and removed from context, only the colour would reveal whether it
represented skin, fabric, lawn, leaves, water or sky.

The texture of one substance simulated in another by an ancient Greek sculpture is a form of visual deception

Not only painters but also sculptors may emphasize texture.
Consider the simulation of actual flesh, soft and warm, carved from
hard cold marble by the ancient Greek sculptor Praxiteles for his
Aphrodite of Knidos (following page), in the mid-fourth century BCE,
the original now lost. The texture of one substance simulated in

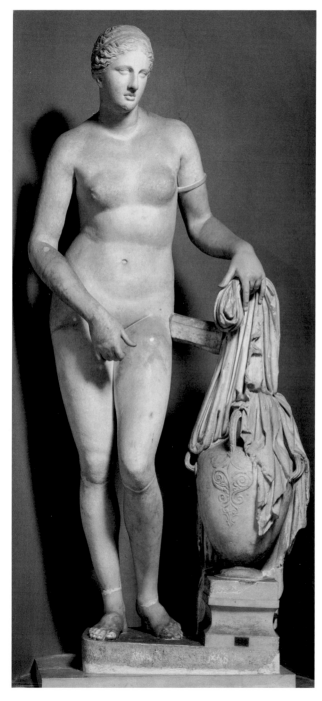

After Praxiteles
Aphrodite of Knidos,
2nd century CE
Roman copy of a Greek
original by Praxiteles,
mid-4th century BCE
Marble, height 204 cm
(80⅜ in.)
Vatican Museums,
Vatican City, Rome

**Praxiteles was one
of the most famous
sculptors of Greek
antiquity. The original
of this statue was the
first life-size female nude
produced by a Greek
sculptor. To create the
illusion of a living person
from stone requires
notable artistry.**

another by this sculpture is a form of visual deception – and an impressive display of the sculptor's skill.

A different use of texture in sculpture capitalizes on the innate ability of certain materials to convey sensations. Consider the Romanian-born sculptor active in France, Constantin Brâncuși's *Bird in Space* (below). Brâncuși made several versions of this sculpture in marble, but others, such as the work illustrated here, cast in 1928, are made of smooth, sleek, polished bronze and are especially effective in conveying a sense of the bird's soaring flight.

Constantin Brâncuși
Bird in Space, cast 1928
Bronze, 137.2 x
21.6 x 16.5 cm
(54 x 8½ x 6½ in.)
Museum of Modern Art,
New York

Brâncuși took an abstract approach to sculpture, striving to represent the essence of the subject he was sculpting instead of its exact form. Thus, Brâncuși suggests the flight of the bird, rather than the bird itself, with this smooth and shiny slender shape.

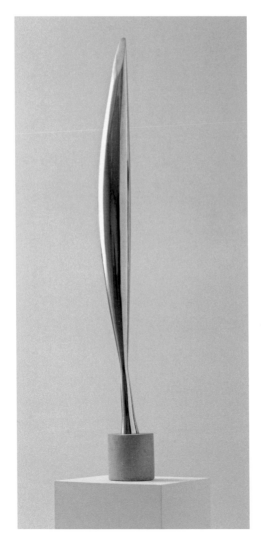

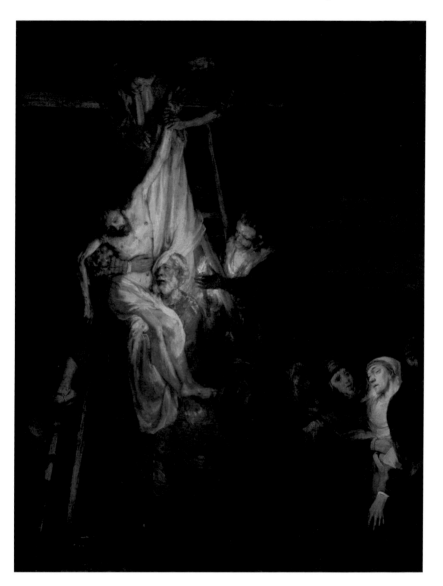

Rembrandt workshop
*Descent from the
Cross*, 1650–52
Oil on canvas,
142 x 110.9 cm
(55⅞ x 43¾ in.)
National Gallery of Art,
Washington, DC

Rembrandt was a master
of using light to focus
the viewer's attention,
a skill he passed on
to his students. Light
simultaneously balances
the composition,
indicates who the most
important figures are and
creates emotional drama.

LIGHT

Light, used in a variety of ways, serves different purposes in painting, sculpture and other visual arts. The Dutch Baroque artists gave special emphasis to light effects in their paintings. In the *Descent from the Cross* (1650–52; opposite), now thought to be from Rembrandt's workshop with his involvement, the source of light is the torch in the centre of the painting held by a man halfway up the ladder. Light dramatically focuses the viewer's attention on the most important people – as if on a theatre stage, Christ is in the main spotlight and his mother Mary in the secondary spotlight, increasing the clarity of the narrative.

The French Impressionists analysed light through the innovative method of broken colour, in which each hue is broken down into its component colours. Thus if an area is intended to appear as green grass, touches of yellow and blue are applied and, when seen from a distance, are supposed to mix in the viewer's eyes, enhancing the luminosity of the colours. Intrigued by light, Claude Monet used broken colour to capture the fleeting effects of natural sunlight in his many paintings of Rouen Cathedral, represented here by *Rouen*

Claude Monet
Rouen Cathedral:
The Portal (Sunlight), 1894
Oil on canvas,
99.7 x 65.7 cm
(39¼ x 25⅞ in.)
Metropolitan Museum
of Art, New York

Monet, in keeping with the interests of the French Impressionists, studied and recorded changing natural light. He chose medieval Rouen Cathedral because he could study the light at length from his room across the square. The subject was not selected for religious reasons (Monet was agnostic), but because, as Monet said, it gave him the opportunity to paint the space between his eyes and the façade.

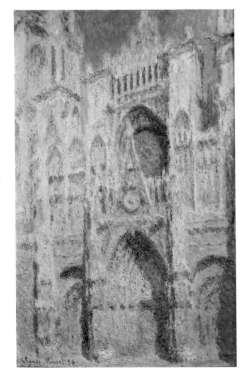

Cathedral: The Portal (Sunlight), (1894; previous page). Although the Gothic cathedral is actually grey stone, Monet used no grey paint in his analysis of light. In 1892 and 1893 he painted more than thirty canvases of the façade on site, touched up in his studio in 1894. He worked on the canvases sequentially, moving from one to the next as the light changed at different times of the day.

The innovative American artist Dan Flavin made an entirely different use of light in his *untitled (in honor of Harold Joachim) 3* light sculpture (1977; below). Much of Flavin's professional career was devoted to discovering the aesthetic possibilities of light – not the natural light that fascinated Monet, but the artificial lights sold in hardware shops! Flavin, among the founders of Minimalism and favouring simple forms, used commercial fluorescent tube lights as his medium, which he arranged into compositions of shapes and vibrant colours. Critics have questioned whether constructions made of commercial fluorescent lights (which contain hazardous mercury vapour) qualify as art.

Dan Flavin
untitled (in honor of Harold Joachim) 3, 1977
Fluorescent light and metal fixtures, 243.8 x 243.8 x 25.4 cm (96 x 96 x 10 in.)
The Dan Flavin Art Institute at Dia Bridgehampton, New York

Flavin made creative use of commercially available fluorescent lights. Although light may be used to illuminate a work of art, here it is used as an artistic medium in itself.

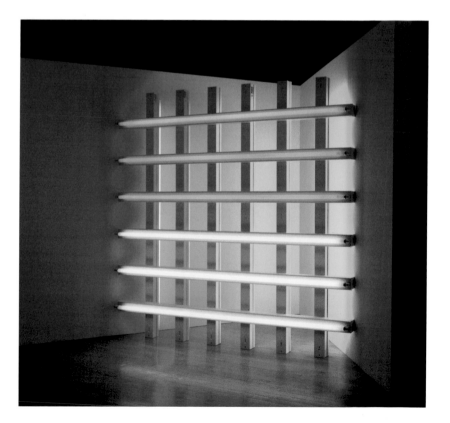

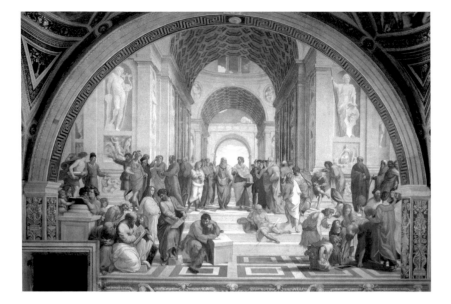

Raphael
School of Athens, 1509–11
Fresco, 5 x 7.7 m
(16 ft 5 in. x 25 ft 3 in.)
Stanza della Segnatura,
Apostolic Palace,
Vatican City, Rome

**One of the great painters
of the Italian High
Renaissance, Raphael
did much of his work in
the Vatican. His paintings
are praised for their
seemingly effortless
charm and perfect
compositions. By
combining various
methods, including
linear perspective,
Raphael seems to
obliterate the
picture plane and
create an illusion of
vast pictorial space.**

SPACE

Artists create illusions of three dimensions on two-dimensional
surfaces using a variety of methods. When employed consistently
and in combination, it is possible to trick the viewer's eyes,
producing the impression that the painted scene exists in a space
behind the picture plane – the surface on which the artist has
created the painting. The picture frame becomes a window through
which we can look or a doorway through which we are able to enter
the artist's world.

The Italian High Renaissance painter Raphael's *School of
Athens* (1509–11; above), a large wall fresco, utilizes many of the
methods available to an artist. Perhaps the simplest indicator of
location in space is overlap, which implies that one object is in
front of, or behind, another. Relative size uses the fact that larger
objects appear closer than smaller objects. The position of objects
lower in a composition suggests they are closer than those placed
higher. Highlights and shadows may make an object appear three
dimensional by modelling it to indicate changes in the surface
planes. Foreshortening a figure or object by drawing the proportions
as if compressed suggests that it is not parallel to the picture plane
but instead recedes on an oblique angle into depth.

Linear perspective and atmospheric perspective are often
used by painters to create a sense of depth. Linear perspective
is especially effective in creating convincing illusions of three-

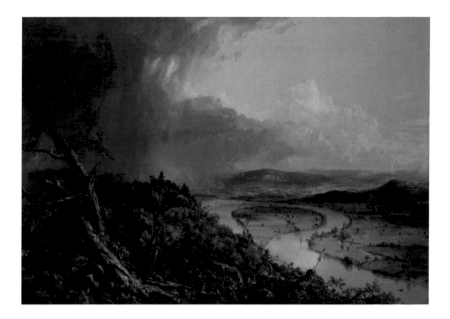

dimensional interiors and exteriors of buildings. Diagonal lines appear to recede into space when drawn to converge towards one or more 'vanishing points' on the horizon line. The appearance of great depth created by the architectural setting of Raphael's *School of Athens* is the result of using centralized, one-point linear perspective.

-

Atmospheric perspective makes use of the principle of advancing and receding colours

-

Atmospheric (aerial) perspective achieves an illusion of depth by copying in paint the optical fact that the atmosphere modifies our perception of objects at a distance, causing them to appear less distinct and their colours less intense. Atmospheric perspective makes use of the principle of advancing and receding colours (see page 40). Landscape painters employed this to advantage, including those of the American Hudson River School, as seen in Thomas Cole's *View from Mount Holyoke, Northampton, Massachusetts, after a Thunderstorm – The Oxbow* (1836; above).

Sculptors make use of space in different ways. Comparison of two versions of the same subject, both carved of marble by

Thomas Cole
View from Mount Holyoke, Northampton, Massachusetts, after a Thunderstorm – The Oxbow, 1836
Oil on canvas, 130.8 x 193 cm (51½ x 76 in.)
Metropolitan Museum of Art, New York

Cole, founder of the Hudson River School, focused on evocative views of New York's Hudson Valley landscape. While Raphael emphasized linear perspective, Cole used atmospheric perspective to give depth to his landscape.

Below left: Michelangelo
David, 1501–4
Marble, height 5.17 m
(17 ft)
Galleria dell'Accademia,
Florence

**Michelangelo portrays
the shepherd boy David
as static, standing calmly
before the conflict with
the giant Goliath.**

Italian sculptors, illustrates this. The High Renaissance sculptor Michelangelo depicts his figure of *David* (below left), carved in 1501–4, in contemplation, standing with his weight on one leg in the antique *contrapposto* (counterpoise) pose as he looks towards his enemy. Michelangelo's *David* does not move – his strength is latent.

The space between the two adversaries is filled with tension

**Below right:
Gianlorenzo Bernini**
David, 1623–4
Marble, height 1.7 m
(5 ft 6 in.)
Galleria Borghese, Rome

**Bernini studied
Michelangelo's work in
Rome but developed a
more dynamic style.**

In contrast, the Baroque sculptor Gianlorenzo Bernini's overtly animated *David* (below right), carved in 1623–4, thus more than a century later, pivots dramatically in space at the instant before releasing the stone from his sling. To complete the meaning of Bernini's *David*, the viewer intuitively implies the presence of Goliath, charging the space between the two adversaries with tension. So effective is the illusion that visitors to the gallery that houses this sculpture avoid standing in the implied line of fire!

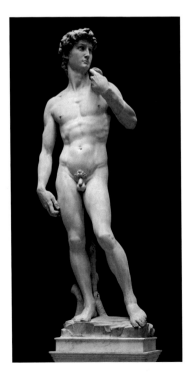

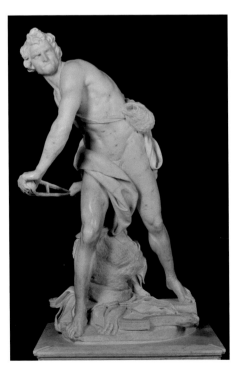

COMPOSITION

In a work of art, the organization of the visual elements creates the composition. The principles of balance, proportion and unity characterize a successful composition.

Balance

Human nature seeks balance – it makes us feel comfortable. The simplest form of balance is symmetry. If a line down the centre of a composition divides it into two identical mirror images, it exhibits perfect bilateral symmetry, as is true of Flavin's *untitled* light sculpture (page 50). However, if the two sides of a composition are similar, but not identical, this is relieved bilateral symmetry, demonstrated by Raphael's *School of Athens* (page 51). If the two sides of a composition are entirely different, this is asymmetry, meaning 'without symmetry'. The *Descent from the Cross* from Rembrandt's workshop (page 48) is asymmetrical yet the composition appears balanced due to the ingenious distribution of light and dark areas.

The centre of a composition exerts a certain force

In order to achieve balance in a composition, an artist may make use of visual force (or visual weight). Some aspects of a work of art may attract our attention sooner and for longer than others – they are more eye-catching. In general, forms that are larger in size, brighter in colour, more visibly textured and imply movement exert greater visual force than forms that are small, dull in colour, indistinctly textured and static. In addition, the centre of a composition exerts a certain force, drawing our eyes to it, presumably because we are accustomed to finding the 'centre of attention' at the physical centre of a composition. If the artist has not provided it for us there, we supply it by implying it. The Italian Gothic artist Giotto used this visual phenomenon cleverly in his fresco of the *Entry of Jesus into Jerusalem* (c.1305; opposite), in which the next step the donkey takes will move Jesus into the very centre of the painting, thereby implying movement.

Proportion

This refers to the relative size of the components in a composition. The idea that certain mathematically derived proportions are more visually satisfying than others appears in antiquity. The ancient

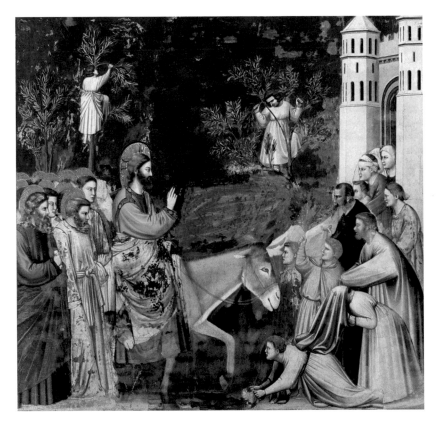

Giotto
Entry of Jesus into Jerusalem, c.1305
Fresco, 200 x 185 cm (78¾ x 72⅞ in.)
Arena Chapel, Padua

The Italian painter Giotto, key to the history of western painting, broke with the earlier medieval flat, two-dimensional style and introduced more volumetric figures as well as human emotion. In the *Entry of Jesus into Jerusalem*, we visually relocate Jesus to the centre of the composition, where we instinctively feel he belongs.

Salvador Dalí
The Sacrament of the Last Supper, 1955
Oil on canvas,
166.7 x 267 cm
(65⅝ x 105⅛ in.)
National Gallery of Art,
Washington, DC

Salvador Dalí created an eccentric personal Surrealist personality to go with his painting style. He used the golden ratio to determine the dimensions of this canvas and a portion of a dodecahedron – a reference to the twelve apostles – that floats in the sky.

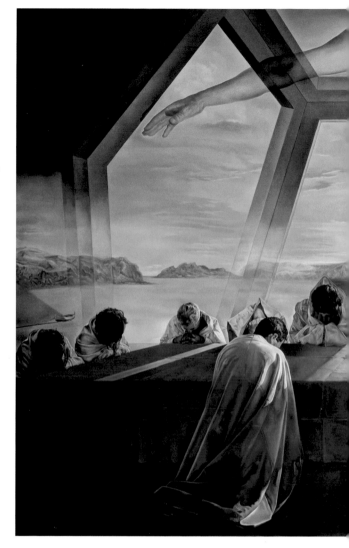

Greeks devised the golden ratio, also referred to as the golden mean, golden section or golden rectangle. Expressed as (a+b)/a = a/b, or the smaller of two dimensions is to the larger as the larger is to the whole, the exact ratio is 1.61803398875:1. This ratio serves to determine the dimensions of, for example, a pleasingly proportioned rectangle. The Spanish Surrealist Salvador Dalí used it for his 1955 painting of *The Sacrament of the Last Supper* (above).

Ideal proportions for the human body have long intrigued artists. The ancient Greeks and Romans turned to mathematics

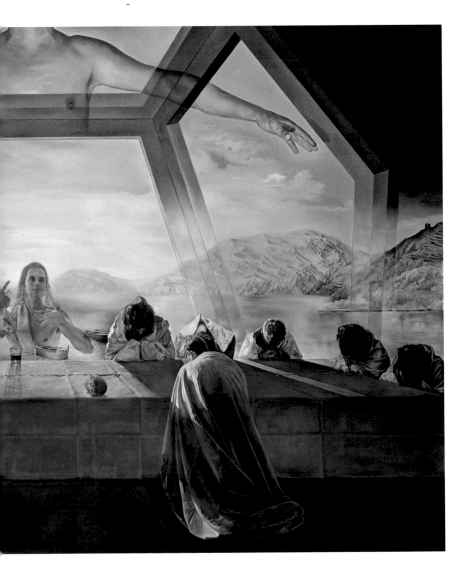

to determine the most desirable dimensions, as noted on page 28. This idea persisted through the history of art: the Italian High Renaissance ideal displayed by Michelangelo's *David* (1501–4; page 53 left) derives from study of the classical ideal.

Unity

A composition has unity if all parts appear connected and cohesive. The repetition of similar shapes, brushstrokes, textures, colours or other elements may achieve unity in an artwork. For example,

Seurat's use of the pointillist painting technique in *A Sunday on La Grande Jatte – 1884* (page 45) unifies the composition by the consistent shape and size of the brushstrokes. Monet's brushstrokes with thick paint of broken colour on his *Rouen Cathedral* (page 49) result in a rough surface texture that consolidates all parts of the painting.

Picasso fused *The Tragedy* (1903; opposite) by use of the colour blue throughout – including the sandy shore and the skin of the people. However, the notion of using similar features throughout a work of art, if taken too far, results in monotony. Consequently, it is advisable to have both unity and variety, achievable by using elements that are similar rather than identical.

-

The Tragedy is an extreme example of the use of the colour blue to elicit emotion

-

Pablo Picasso
The Tragedy, 1903
Oil on wood,
105.3 x 69 cm
(41½ x 27¼ in.)
National Gallery of Art,
Washington, DC

Picasso is often considered the greatest artist of the twentieth century. Over a long career, he worked in many styles, including his early Blue Period, represented by this painting. He would go on to his Rose Period, various innovative forms of Cubism, his Classical Period and more. See pages 154–9 on Picasso.

EMOTION

The elements of art may be used to convey powerful emotions – positive, negative and everything in between. In Pablo Picasso's *Tragedy*, although the nature of the tragedy is not made clear, a profound sense of sadness is conveyed by the dominance of the colour blue, the jagged black lines, the hunched poses of the figures and their downward gazes. The connection between physical position or direction and emotion is evident when we tell a person who is 'feeling low' or 'feeling down' to 'hold your head high', or that things are 'looking up'. Similarly, the emotional connotations conveyed by colours are part of our language, for we may say we are 'feeling blue', 'in a blue mood' or 'have the blues'.

-

Colour may convey meaning

-

The Tragedy is an extreme example of the use of the colour blue to elicit emotion. Colour carries meaning, evidenced when we say an angry person 'sees red' or someone new to a job is 'green'. The importance of the psychological effects of the colour of wall paint for different kinds of rooms is well known: the soothing tone suitable for a hospital waiting room is unlikely to be the same as that selected for a nightclub dance hall.

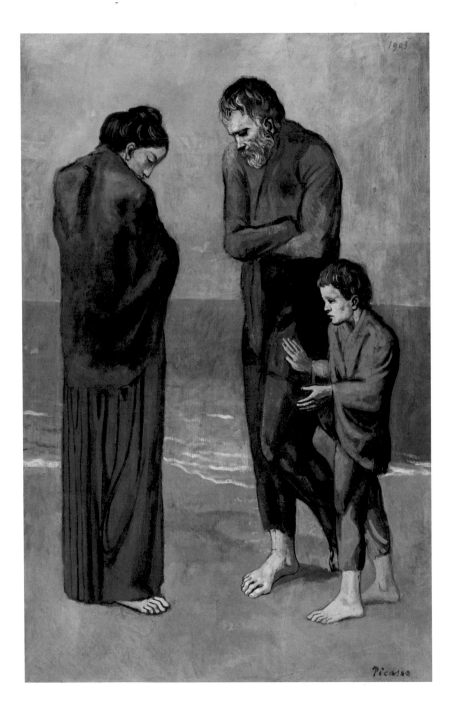

STYLE IN ART

The style of a work of art results from the way in which the visual elements are used. The artist's personal style is what makes the French sculptor Auguste Rodin's portrayal of *The Kiss* (below), carved c.1882, look so very different from the same subject carved by Constantin Brâncuși (opposite below) in 1916. The differences between these two stone sculptures, created close in time, location and culture, demonstrate the impact of each artist's personal style.

In addition to referring to an artist's personal approach, the term 'style' also distinguishes periods in the history of art. Greatly simplified, the main periods of western European art are prehistory; Greek and Roman antiquity; Early Middle Ages; Romanesque; Gothic; Early and High Renaissance; Mannerism; Baroque; Rococo; Neoclassicism; Romanticism; Realism; Impressionism and Post-Impressionism; Fauvism; Cubism; Futurism; Dadaism; Surrealism; Minimalism; Postmodernism; and the almost countless art 'isms' of more recent years. Although it has long been customary to

Auguste Rodin
The Kiss, c.1882
Marble, 181.5 x
112.5 x 117 cm
(71½ x 44¼ x 46 in.)
Musée Rodin, Paris

Rodin reacted against the sculptural norms of his day and, after a trip to Italy, said, 'It is Michelangelo who has freed me from academic sculpture.' Rodin used the human body, depicted with extraordinary naturalism, as his device to convey sensations without words.

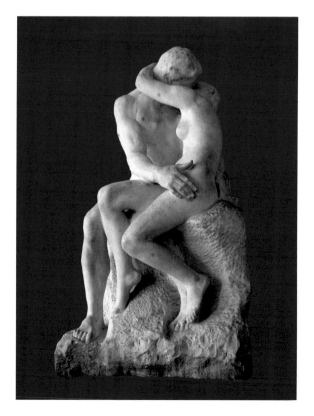

distinguish artistic styles by geographic location – as Italian Renaissance or French Impressionism – this is less and less valid. Increasing globalization and the ease with which ideas spread internationally through technology and travel make linking an artistic style to a specific country progressively less accurate and increasingly obsolete.

A tendency to a multiplicity of styles achieving popularity simultaneously, rather than one dominant style, is gradually growing, especially in the later twentieth and early twenty-first centuries. Recent styles range from photographic hyperrealism to total abstraction. At one extreme are works of art that genuinely trick the viewer's eyes, convincing us we see something that, in fact, we do not. Such works are very naturalistic, so meticulously rendered that they appear factual and actual. Other works of art are stylized, nature's imperfections obscured or perhaps modified for aesthetic reasons. Moving still further from observable reality, when a work of art contains no recognizable or identifiable subject and

Constantin Brâncuși
The Kiss, 1916
Limestone, 58.4 x
33.7 x 25.4 cm
(23 x 13¼ x 10 in.)
Philadelphia Museum
of Art, Philadelphia

Brâncuși, in contrast to Rodin, created his sculpture when Cubism was in vogue and his simplified couple, far from nature, literally forms a cube and, as the saying goes, only have eyes for each other.

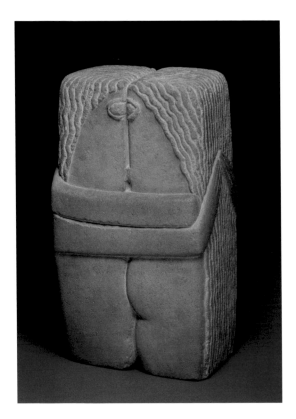

is non-representational, it is abstract art. Whether an intellectual simplification of primary colours and geometric shapes or all colours and curves, abstract art has no connection to the visible world.

WHAT TO LOOK FOR WHEN ANALYSING ART

What might you consider when analysing a work of art? There is a difference between simple description and thoughtful analysis. To describe the colours in Picasso's painting *The Tragedy* (page 59) as various shades of blue is accurate – but a superficial observation. To analyse these colours, noting that the many cool blue tones enhance the sense of sadness that pervades this painting and its 'blue mood', is more informative. By probing into Picasso's life, discussion of this painting would place it in the artist's Blue Period, 1901–4, when his paintings were literally – almost monochromatically – blue and focused on subjects of sad, destitute people. There is an autobiographical aspect here: Picasso was himself impoverished at this time and his dear friend, Carles Casagemas, had committed suicide in February 1901.

You can enhance your experience with a work of art significantly by learning about the person who created it. If the artist is unknown, try to understand something about the culture the work of art represents. Is the work typical of that artist and/or era? Consider the subject portrayed and its meaning (see pages 98–129). What do you notice about the artist's style? How have the materials and techniques used to create the work influenced the result?

Comparing the same subject painted by two artists from different times and places may prove especially illuminating

Certain characteristics of a work of art may become more apparent, readily recognized, when evaluated in relation to another work. Comparing an early Rembrandt to a late Rembrandt gives you a greater understanding of the trajectory of his personal life as well as his career as an artist. Comparing the same subject painted by two artists from different times and places may prove especially illuminating: comparing Titian's *Venus and Adonis* from the 1550s to Rubens's painting, probably from the mid-1630s, of the same subject (both in the Metropolitan Museum of Art, New York) reveals much about both the Renaissance in Venice and the Baroque in Flanders respectively.

Camille Claudel
La Valse (*The Waltz*),
1889–1905
Glazed stoneware,
41.5 x 37 x 20.5 cm
(16¼ x 14½ x 8⅛ in.)
Musée Camille Claudel,
Nogent-sur-Seine

Claudel was initially a student of the much older Rodin, but became his lover and his equal in talent as a sculptor. She is known for the overt sensuality of her figures. Tragically, following the death of her father and protector, Claudel was institutionalized by her family for the last thirty years of her life.

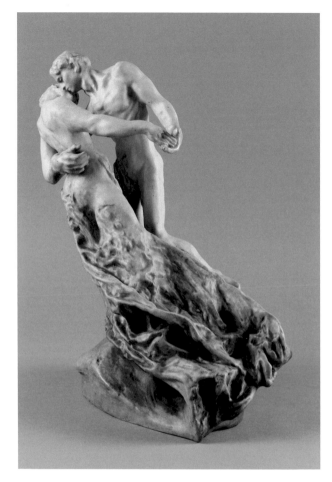

Comparing works of art created by an artist and pupil may give insight into the skills of both, as well as the relationship between them. The young Leonardo da Vinci was apprenticed to Andrea del Verrocchio and painted portions of Verrocchio's *Baptism of Christ* (c.1470–75; Galleria degli Uffizi, Florence). According to the sixteenth-century author Giorgio Vasari in his *Lives of the Artists*, these were the best parts of the picture, leaving Verrocchio so chagrined that he 'never touched colour again'. The result of the relationship between the French Impressionist sculptor Auguste Rodin and his student Camille Claudel was very different, for she became his model, collaborator and lover. Their sculptural styles were so similar as to be indistinguishable – in fact, she was enraged to discover Rodin had signed his name on her work.

Consider the limitations of the medium
in which the artist worked

How can you assess quality in a work of art? At minimum, the artist should possess adequate skill to convey the intended ideas visually. Beyond this, if the assessment is to be fair, the constraints faced by the artist and, consequently, what was possible warrant examination. Consideration should be given to the limitations of the medium in which the artist worked: egg tempera, the only option available to a panel painter during the Middle Ages, dries quickly and to a uniformly matte surface, making illusions of texture nearly impossible to create. In contrast, oil paint, developed fully during the Renaissance, dries slowly, varies in viscosity and permits the artist to achieve any visual effect she or he is capable of creating. Similarly, to find fault with a mosaicist for lack of naturalism in a work is to criticize a characteristic of the medium rather than the skill of the artist (see the next chapter).

To some extent all creative accomplishments relate to,
and depend on, the past

What constitutes 'great' art? This important question is unlikely ever to have a single, widely accepted answer. Why do some styles, such as classical Greek, and some artists, such as Rembrandt, have enduring appeal while others do not? This is true also in other fields, such as music and literature. You might take into consideration whether the work is intelligent and fresh. Creative and innovative? Perhaps even truly novel and unique? Today, most people regard these qualities favourably. Or, in contrast, is it derivative, little more than a repetition of earlier artists' ideas? Yet to some extent all creative accomplishments relate to, and depend on, the past. The world in which we live and the past that shaped that world, influence at least to a small degree even those artists who pride themselves on being 'naïve' or 'self-taught'.

The goal is not necessarily to like all works of art you see, but to be open-minded in your evaluation. When you visit museums, galleries and other places that exhibit art, please try to look at works created by unfamiliar cultures, perhaps distant in time and location, and consider the new ideas encountered. Do your best to discard

the almost unavoidable preconceived opinions and prejudices. Strive
to be receptive to each work of art according to its own aesthetic
and purpose. Keep in mind that the definition of 'art' in non-western
cultures may complicate the notion of what constitutes 'good art'.
Some people may consider objects referred to as 'primitive' or
'craft' or 'folk art' to be of lower status than the fine arts. But this
is a modern western attitude, unknown to the cultures to which we
apply it.

KEY ELEMENTS

Colour:
 Primary, secondary, complementary
 Hue, intensity/saturation, value, tint/pastel, shade
 Colour blindness
Line:
 Hatching, cross-hatching
 Implied line and shape
 Line versus colour debate
Texture:
 Implied rather than actual
Light:
 Broken colour
 Artificial light
Space:
 Overlap, relative size, modelling, foreshortening
 Linear perspective, atmospheric perspective
 Contrapposto
Composition:
 Balance
 Proportion
 Unity
 Visual force
Emotion:
 Role of physical position
 Use of colour
Style in art:
 Personal style
 Styles in the history of art from hyperrealism to abstraction

MATERIALS AND TECHNIQUES

-

He who works with his hands is a laborer;
He who works with his hands and his brain is an Artisan;
He who works with his hands, his brains and
his heart is an Artist

-

Boys' Club Federation, New York City
1923

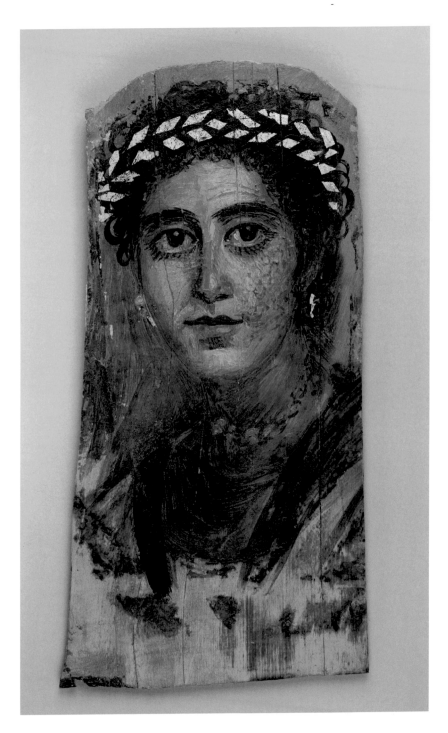

Unknown artist
Portrait of a Young Woman from a Fayum mummy, Roman Egypt, 90–120 CE
Encaustic and gold leaf on limewood, 38.1 x 18.4 cm (15 x 7¼ in.)
Metropolitan Museum of Art, New York

In encaustic, the binder used is wax. Encaustic mummy portraits were made throughout Egypt, but those surviving in the best condition are the strikingly lifelike examples from the Fayum area. Encaustic is still used today.

Understanding how artists produce paintings, sculptures and other works of art will enrich your experience. What resources, tools and methods were, and are, available for an artist to use? What can an skilled artist working in a particular medium accomplish and what is beyond reach? To what extent does the medium affect the final effect?

PAINTING AND RELATED MEDIA

All types of paint consist of pigment in the form of ground particles of coloured material and a binder, which is essentially the glue that holds the particles of pigment together and enables them to adhere to a support.

Encaustic

Encaustic, one of the earliest painting techniques, is made by mixing pigment with hot wax (traditionally beeswax) as the binder, either as a liquid or paste depending on the temperature to which it is heated. The artist usually applies this paint to a wood panel, as seen in mummy portraits from the Fayum area in Egypt (opposite), the oldest surviving encaustic paintings.

Advantages of encaustic are its extreme durability and permanence of the colours. When polished, the rich waxy quality of the surface acquires a soft sheen. Disadvantages are the need to keep the paint hot while working, and the cumbersome process and equipment required to do so. If subjected to extreme heat (above 90° C/194° F), encaustic paintings will melt.

Today electric palettes, painting irons and hot air guns are available and an artist may purchase small blocks of coloured filtered beeswax mixed with resin or synthetic waxes in a range of colours. The addition of resins and other materials that increase elasticity make it possible to use encaustic on flexible surfaces such as paper and canvas.

Fresco

Large scale paintings on walls and ceilings are usually created using fresco. The two basic types are *buon fresco* (also called *fresco buono*), painted on wet plaster, and *fresco secco*, painted on dry plaster. *Fresco* means 'fresh', *buon* means 'good' and *secco* means 'dry' in Italian. The fresco technique, already highly developed in ancient Roman times, as seen on the walls of homes excavated at Herculaneum and Pompeii, preserved by the eruption of the volcano Vesuvius in 79 CE, flourished during the Italian Renaissance.

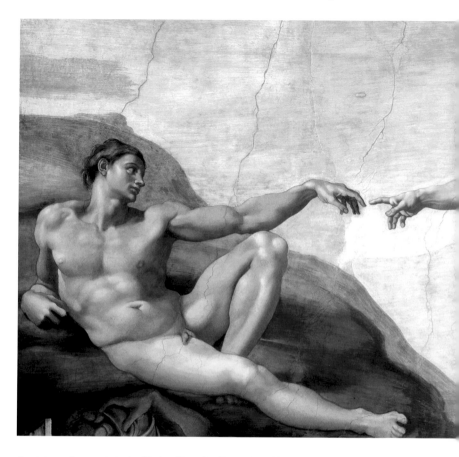

A celebrated example is the Sistine Chapel ceiling, painted by
Michelangelo, in the Vatican (1508–12; above and pages 102–3).

To create a fresco, the surface is smoothed with layers of plaster,
progressing from the coarsest to the finest. The *giornàta*, meaning
'day's work' in Italian, is determined and covered with a very smooth
thin layer of plaster known as the *intonaco*. The artist paints with
finely ground pigment mixed with water on the wet plaster, working
rapidly in a race against the drying time of the plaster. As the plaster
dries, capillary action absorbs the pigments and embeds them in the
calcium carbonate crystals of the plaster. Because the paint binds
with the plaster as it dries, *buon fresco* is extremely durable.

An artist may touch up a *buon fresco* painting using *fresco secco*,
and apply details using egg tempera, but neither will adhere well
because they form merely a surface film. Pigments suitable for *buon
fresco* are limited due to chemical incompatibility with the alkalinity
of the plaster that prohibits almost all colours of vegetable origin.

Michelangelo
Creation of Adam,
detail of ceiling, c.1512
Buon fresco,
2.8 x 5.7 m
(9 ft 2¼ in. x 18 ft 8⅛ in.)
Sistine Chapel,
Vatican City, Rome

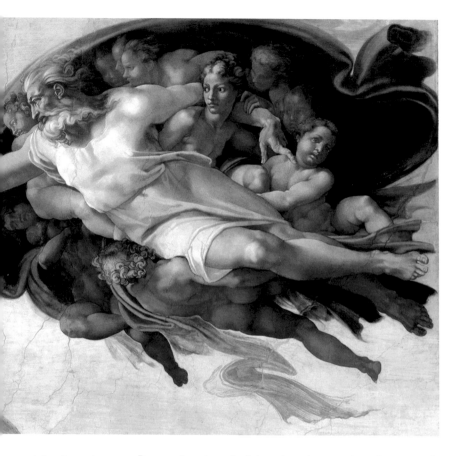

In *buon fresco*, paint consisting of only pigment and water is applied to a wet plaster surface. Because the pigment penetrates the plaster as it dries, true fresco is very durable. Michelangelo worked on the Sistine Chapel ceiling lying on his back on scaffolding, high above the floor, paint dripping on his face.

Because the colours dry lighter than when wet, the artist must apply colours darker than desired in the finished painting and matching colours applied on successive days is difficult.

In *fresco secco* a dry lime plaster wall is thoroughly soaked with limewater the night before painting and again the morning of the day of painting. Limewater is water mixed with calcium hydroxide, also called slaked lime, made by combining water with calcium oxide. While the wall is wet, the artist paints with a mixture of ground pigment, water and limewater or with ground pigment mixed with a binder such as casein, a powder made by drying curds from sour milk. Another technique is to paint on dry plaster with distemper (not to be confused with egg tempera, discussed on pages 74–5), using a mixture of earth colours, water and a binder of plant or animal origin. An excellent example of *fresco secco* is the nave vault of the Church of Saint-Savin-sur-Gartempe, France, painted in the late eleventh to early twelfth century with Old Testament scenes.

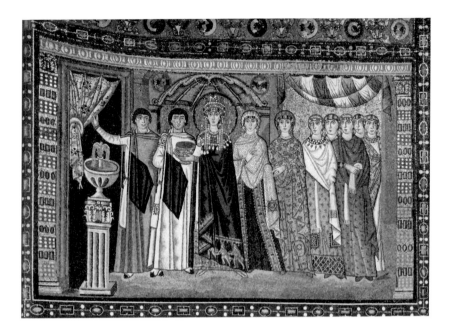

Mosaic

Mosaic, like *buon fresco*, uses wet plaster. Instead of painting on it, the artist presses small cubes of coloured material called tesserae (a term derived from the Greek word for 'four' because of the four corners visible on each cube) into the plaster. The last step is to fill the narrow spaces between the tesserae with mortar (grout).

The technique was already well established and used extensively in ancient Roman times. Roman mosaicists used marble and other types of stone, limiting the colours available to those provided by nature. During the fourth century CE, artists introduced coloured glass tesserae and gold tesserae, greatly increasing the range of colours and the richness of effects possible. The pair of mosaics of the Byzantine Emperor Justinian and Empress Theodora (c.547; above) in the Church of San Vitale in Ravenna glitter with glass tesserae. The mosaicist varied the size of the tesserae, using smaller pieces for the faces than for the background. Theodora's crown and necklace include round pieces of mother-of-pearl.

Alternatively, tesserae may be made of coloured paste, produced by mixing pigment with cement and powdered glass, as in the twelfth-century mosaics of the Palatine Chapel in Palermo. Rather than using cubes of solid gold, a thin layer of gold leaf was applied to a glass cube, or gold leaf was placed between two pieces of nearly clear glass. A mock gold known as 'mosaic gold',

Unknown artist
Empress Theodora and her Attendants, c.547
Mosaic, 2.64 x 3.66 m
(8 ft 8 in. x 12 ft)
Church of San Vitale, Ravenna

Although early mosaics were made of stone, later mosaics of more colourful glass and gold sparkled, especially when seen by candlelight. Under Theodora's husband, Emperor Justinian (depicted in a companion mosaic in San Vitale), Byzantine art thrived.

made from tin bisulfide, an inexpensive pigment with a high lustre, effectively simulated both gold leaf and powdered gold as early as the thirteenth century.

The artist may intentionally use glass and gold to transform solid surfaces into shimmering crystalline screens

Mosaic, especially suitable for use on large surfaces, such as ceilings, walls and floors, is very durable and holds up well indoors and outdoors. The artist may intentionally emphasize the decorative quality of the medium, using the glass and gold to create sumptuous environments, transforming solid surfaces into shimmering crystalline screens. However, because the tesserae are readily visible (with the exception of the rare micro-mosaic), the technique eliminates the possibility of creating a genuinely naturalistic image.

Manuscript Illumination

The word manuscript derives from *manus*, meaning 'hand', and from *scribere*, meaning 'to write' in Latin. Correctly speaking, pictures decorated with gold in manuscripts are illuminations rather than illustrations. Each page of a manuscript is a folio, the front being the *recto*, abbreviated as *r*, and the back the *verso*, abbreviated as *v*. The *Book of Kells*, created c.800, one of the most famous illuminated manuscripts, includes the *Symbols of the Four Evangelists* (following page), showing Matthew (the man), Mark (the lion), Luke (the ox) and John (the eagle).

The usual material for manuscript folios is animal skin, known as parchment or vellum. The word parchment derives from the name of the Greek city of Pergamum in western Turkey. The Roman naturalist Pliny the Elder (d.79 CE) wrote that King Eumenes II (197–158 BCE) of Pergamum invented parchment when there was a trade blockade on papyrus. The word vellum comes from *veau*, meaning 'calf' in French. Technically, parchment is cow skin while vellum is that of a young calf; the finest is 'uterine vellum', the skin of a stillborn or newborn calf. Other animals' skins could suffice.

After the scribe's work was complete, the illuminator began to apply the colours using various types of binders. Glair, made from egg white and water, described as having a 'rank odour', was standard during the Middle Ages. Gum arabic, a water-soluble tree gum, forms a thin jelly in water. Animal size (or glue), almost a pure gelatin made by boiling bits of parchment and skin, served especially

Unknown artist
Symbols of the Four Evangelists, folio 27v in the *Book of Kells*, gospel book, text in Latin, made in Britain or Ireland, c.800
Calfskin vellum, trimmed: 33 x 25.5 cm (13 x 10⅛ in.)
Trinity College Library, Dublin

Manuscripts, books made by hand especially prior to the development of printing, have folios (pages) of parchment or vellum (animal skin). The *Book of Kells*, a Latin Gospel book named for the monastery of Kells where it was long kept, is among the finest illuminated (illustrated) manuscripts created during the Early Middle Ages.

for blues. Egg yolk, if added to one of the binders above, makes the colours glossier and more lustrous. Ear wax, surely the least expected ingredient, prevents tiny bubbles from forming in glair. After carefully painting the forms, the illuminator went over the drawing with black ink.

Egg Tempera
Egg tempera uses an emulsion of egg yolk and water as the binder. The technique reached its peak during the Late Middle Ages, as seen in the Italian Duccio's *Nativity* (1308–11; opposite), a predella panel from his *Maestà* altarpiece (page 21). The artist worked on an aged wood panel, sealed with a coat of glue, followed by several coats of thick white gesso to form a smooth surface. Application of the gold-leaf background and haloes common in medieval panel paintings precedes the actual painting. It was customary

to underpaint the skin of the more important figures with green, in the belief that this would enhance the reddish flesh tone painted over it. Unfortunately, abrasion of the surface paint may result in a greenish pallor.

Duccio di Buoninsegna
The Nativity with the Prophets Isaiah and Ezekiel, 1308–11
Egg tempera and gold on poplar panel, overall including original frame 48 x 86.8 x 7.9 cm (18⅞ x 34¾ x 3⅛ in.) National Gallery of Art, Washington, DC

Egg tempera, the favoured medium for panel painting during the Middle Ages in western Europe, uses egg yolk as the binder. Although the rapid drying and matte surface limit the effects achievable, it is very durable. Large paintings are made of several panels attached together. Altarpieces often had smaller predella panels below such as these, once part of Duccio's *Maestà* (page 21).

A disadvantage of egg tempera is its extremely quick-drying property

Advantages of egg tempera include the clear crisp images and bright colours (the yellow of the yolk disappears) that change very little over the centuries. The medium has long-lasting durability, as demonstrated by the excellent condition of many medieval paintings. Although the artist can dilute egg tempera with water and it is water-soluble while wet, once dry, the paint is insoluble.

A disadvantage of egg tempera is its extremely quick-drying property that makes blending colours difficult and brushstrokes can only be small. Little illusion of texture is achievable because the surface dries uniformly matte, eliminating the possibility of creating the sparkling surfaces found in oil painting. The albumen of the egg contains sulphur that tends to darken certain pigments, making them unsuitable for use in egg tempera and limiting the range of colours. Due to the somewhat transparent nature of egg tempera, correcting mistakes is problematic. Because of its inflexibility, the artist must apply egg tempera to a rigid surface and cannot use it on canvas.

Oil Paint

Oil paint gradually replaced egg tempera, the change effectuated by a transitional mixed technique. This began in Flanders when Melchior Broederlam applied oil glazes to his egg tempera paintings, such as the *Annunciation and Visitation* (1394–9; Musée des Beaux-Arts, Dijon). A layer of egg tempera followed by a layer of oil utilizes the advantages of each. The fast-drying egg tempera is well suited for use as an underpainting, enabling the artist to continue work almost immediately in oil. Because one is water-based and the other is oil-based, the layers will not dissolve each other.

The slow-drying property of oil facilitates the blending of colours, making it possible to achieve subtle tonal gradations and textural illusions

The oil most commonly used is linseed, made by pressing the seeds of the flax plant (genus *linum*). The slow-drying property of oil facilitates the blending of colours, making it possible to achieve subtle tonal gradations and textural illusions not possible with egg tempera. The artist may start and stop work at any time and may paint over any unsatisfactory parts – which is not necessarily true of other media such as *buon fresco*.

Unlike water-based media that dry lighter, oil colours do not change when dry, therefore allowing the artist to see the final chromatic relationships while working. Because there are no chemical incompatibilities, the colour palette of oil paint is greater than that of fresco or egg tempera. Oil colours are saturated, rich, dense and intense with a natural gloss. The painter may vary the viscosity of oil paint from a thin transparent glaze, made of a little pigment and a lot of oil, seen in Rembrandt's *Night Watch* (1642; pages 140–41), to a thick impasto made of a lot of pigment and a little oil, as in Vincent van Gogh's *Starry Night* (1889; page 146). A single painting may exploit both of these possibilities and everything in between, as does *The Rape of Europa* (1562; opposite), painted by the Venetian artist Titian.

Because oil paint is physically flexible, the artist need not paint on a solid wooden support but may instead paint on canvas. First used in early sixteenth-century Italy, canvas is a sturdy linen fabric made from the fibrous flax plant that is also the source of linseed oil. Preparing a canvas is far less expensive and time-consuming than preparing a wood panel. Oil paints became available commercially

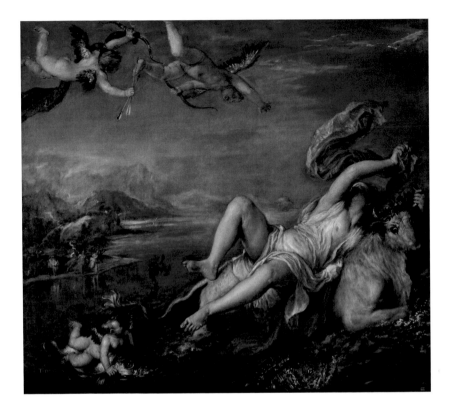

Titian
The Rape of Europa, 1562
Oil on canvas,
178 x 205 cm
(70⅛ x 80¾ in.)
Isabella Stewart Gardner
Museum, Boston

**Oil paint uses a
vegetable oil as the binder
and may be mixed to
any desired consistency.
This versatility allows the
painter to create a wide
range of effects. Titian,
among the first in Italy
to paint with oil on
canvas, founded the
sixteenth-century
Venetian school of
painting in which colour
was valued above line.**

in metal tins and collapsible tubes during the late eighteenth and
nineteenth centuries. Chemically produced pigments appeared in
the nineteenth century, permitting the introduction of a variety
of new colours.

Oil paint, however, has problems that are likely to become
apparent only after many years. Oil tends to darken and yellow,
but may also increase in transparency, revealing revisions to
a composition as a figure gradually grows an odd number of
extremities or an even number of heads! As the upper layers
become transparent, the brown underpainting (customary until the
later nineteenth century) may become more visible than intended
and the entire effect darkened. Further, it was routine to protect
a finished oil painting with a layer of varnish, but this layer was
also likely to darken and yellow over time. In general, oil is not as
permanent as egg tempera. And, for the impatient artist, or the
artist with an impatient patron and a tight deadline, the slow-drying
property of oil is a drawback.

Synthetic Paint

Dispersal of pigment in an acrylic polymer emulsion forms acrylic paint, also called plastic paint. After their commercial introduction as industrial and house paints, artists adopted these paints in the mid-twentieth century. Due to their flexibility, the artist may work on canvas prepared with a polymer primer. Synthetic paints are tough, durable and do not yellow. They resist climatic changes, light and heat better than oil or egg tempera. Artists may apply synthetic paint in many layers. Although acrylic paint dries quickly, addition of a retardant provides more working time. Modelling paste may be added to create texture. The American artist Helen Frankenthaler's *Grey Fireworks* (1982; above) demonstrates the versatility of acrylic paint and some of the many effects achievable.

Synthetic paints, however, lack the oily richness of oil paint and certain alkali-sensitive pigments are incompatible with acrylics. Once dry, acrylic paint becomes insoluble in water and requires a strong solvent for its removal. Acrylic paint is not suitable for use on an oil-primed canvas nor as an underpainting for oils because synthetic paints retain elasticity longer than oils, limiting adhesion. Although many brands are available commercially, some brands do not mix well with others and will curdle.

Watercolour and Gouache

Watercolour and gouache consist of pigment combined with water, a binder such as gum arabic and ingredients like glycerin or

Helen Frankenthaler
Grey Fireworks, 1982
Acrylic on canvas,
182.9 x 301 cm
(72 x 118½ in.)
Private collection

Synthetic paints are easy to work with because they are water-soluble while wet, and a great range of effects may be achieved by adding various substances. Frankenthaler, an Abstract Expressionist, developed a new way of painting directly on unprimed canvas using her 'soak-stain' method.

honey, or both, to improve the consistency and colour, as well as preservatives. While watercolour is translucent, the larger size of the paint particles in gouache and the higher percentage of pigment, make it thicker and more opaque. A single painting may combine both watercolour and gouache, as the American artist Winslow Homer's *Mending the Nets* (1882; below) shows.

Today watercolours and gouache paints are available in tubes and small dried cakes of colour. Due to their fast-drying property and transportability, these paints are favoured for painting outdoors. They are also suitable for studies and preliminary sketches. However, the colours do not appear the same wet as dry, making it difficult to know the final effect while painting.

Winslow Homer
Mending the Nets, 1882
Watercolour and gouache
over graphite on paper,
69.5 x 48.9 cm
(27⅜ x 19¼ in.)
National Gallery of Art,
Washington, DC

Watercolour paints, quick drying and easily carried, are ideal for a sketch by the travelling artist. However, the fact that every brushstroke shows, and mistakes cannot be painted over, makes watercolour one of the most challenging painting media. The American artist Winslow Homer used watercolour and gouache to paint factual depictions of his surroundings.

PRINTS

Prints are works of art usually produced in multiple copies on paper. The editions are limited and each print is numbered. For example, 3/24 written in a lower corner of a print means that it is the third print from a total of twenty-four prints made of this image.

Relief Techniques

To create a relief, a printmaker cuts the design into a block of wood using a gouge, wood chisel or knife, removing the areas not intended to print. Ink applied with a roller adheres to the remaining raised portions. The ink is transferred to a soft piece of paper by applying pressure by hand using a tool similar in shape to a tablespoon. Multiple prints can be made without the need for a printing press. The woodblock prints by Katsushika Hokusai (c.1831–2; below) are exemplary. Colour may be added to each print by hand or, as Hokusai did, by using additional woodblocks. For a woodcut the block is cut with the grain of the tree, whereas for a wood engraving, the block is cut across the grain, offering the advantage that the gouge encounters equal resistance in all directions.

Intaglio Techniques

In contrast to relief printing in which the surface prints, in intaglio, the ink that fills indentations below the surface of a metal plate

Katsushika Hokusai
The Inume Pass in Kai Province (Kōshū Inume tōge), from the *Thirty-six Views of Mount Fuji (Fugaku sanjūrokkei)* series, c.1831–2 Polychrome woodblock print, 25.1 x 37.8 cm (9⅞ x 14⅞ in.) Metropolitan Museum of Art, New York

The Japanese printmaker Katsushika Hokusai produced *ukiyo-e* ('pictures of the floating world') coloured woodblock prints focusing on landscape – his fascination with Mount Fuji is connected with his Buddhist beliefs and the link between this mountain and immortality.

Francisco Goya
And There Is No Help,
from the *Disasters of War*
series, 1810
Etching and drypoint,
plate 14 x 16.7 cm
(5⅝ x 6⅝ in.)
Metropolitan Museum
of Art, New York

**The Spanish Romantic
artist Goya, although
rendered deaf by an
undiagnosed illness,
became First Painter to
the family of Charles IV.
But the *Disasters of War*
intaglio prints were not
published until 1863,
thirty-five years after
Goya's death, due to
their inflammatory
anti-war message.**

is printed. There are several methods of making the indentations. To make an engraving, the printmaker cuts grooves into the metal plate with a gouge or a burin. To make a drypoint, the printmaker scrapes a pointed tool along the plate without removing any metal, but pressing hard enough to kick up a burr (rough edge) on either side of the groove created. Making an etching requires less physical effort: the printmaker covers the surface of the plate with a waxy acid-resistant ground, and then scratches lines through it with a pointed tool. When placed in a mild acid bath, the acid etches the lines where the plate is exposed. Additional techniques are aquatint and mezzotint, which are used to create shades of grey. The Spanish Romantic artist Francisco Goya demonstrates the combination of various intaglio techniques in *And There Is No Help* (1810; above).

Regardless of which technique makes the indentations, the actual printing process for intaglio is the same: the printmaker cleans and warms the plate, then dabs ink onto the surface, pushing it into the indentations, and wipes the surface, leaving ink only in the indentations. The plate is placed on the press bed and covered with damp paper and a printing press blanket/felt.

Henri de Toulouse-Lautrec
Divan Japonais (The Japanese Settee), 1892–3
Lithograph printed in four colours on wove paper,
80.8 x 60.8 cm
(31⅞ x 24 in.)
Metropolitan Museum of Art, New York

The Post-Impressionist Toulouse-Lautrec was the scion of French nobility, but his stunted growth and short stature set him apart from this way of life. Instead, his lithograph posters take us into late nineteenth-century bohemian Paris nightlife.

The plate is run through the press in both directions, thereby pushing the soft paper into the indentations to absorb the ink.

Lithograph

Materials used by printers vary greatly. In woodblock (relief) the image to be printed is made on wood; in drypoint, engraving and etching (intaglio) it is made on metal; and in lithography it is made on stone. In relief printing the surface prints and in intaglio the indentations below the surface print, but in lithography, rather than a change in surface level, acid is used to make a chemical change to the surface of a limestone block. The German actor Alois Senefelder invented the technique of lithography in 1796, based on the simple fact that oil and water do not mix. The term derives from the ancient Greek for 'stone' (*lithos*) and 'to write' or 'to draw' (*graphein*).

To make a lithograph, the lithographer draws the image with a greasy substance such as a crayon on a smooth limestone block. The image is treated with a mixture of mild acid and gum arabic, causing a chemical change in the areas not protected by the grease. The lithographer removes the stone from the acid bath but keeps it wet with water. Oil-based ink rolled onto the stone adheres only to the greasy areas. The stone is placed on the printing press bed, covered with a sheet of paper and run through the press. Multiple colours in a print require either multiple stones or a single stone ground down between colours and reused.

The French Post-Impressionist Henri de Toulouse-Lautrec's skill with lithography appears in *Divan Japonais* (1892–3; opposite). More recently, lithographers have used metal plates and even plastic rather than stone. Offset lithography is a commercial process (see page 105); the image is printed onto an intermediate surface before the final sheet, thus preserving the quality of the original plate.

Silkscreen

Although the technique of serigraphy, also known as silkscreen or screen printing, appears as early as the Song dynasty (960–1279) in China, the word serigraph was first used in the 1930s to differentiate screen printing used to create fine art from its commercial use. The word derives from the Latin for 'silk' (*sericum*) and the ancient Greek for 'to write' or 'to draw' (*graphein*).

A silkscreen is a piece of finely woven silk stretched over a wood frame. A stencil, which may be cut from paper, plastic, or a thin sheet of another material, is used to block the areas that are not to be printed. The printer places a piece of paper under

Andy Warhol
Campbell's Soup I: Chicken Noodle, 1968
Screenprint on paper,
88.9 x 58.7 cm
(35 x 23⅛ in.)
Andy Warhol Museum,
Pittsburgh

The American leader of Pop Art, Andy Warhol, began his career as an illustrator. He went on to work in a multitude of media, but the one for which he is best known is silkscreen. He used this commercial printing technique to produce multiple images of mass-produced commercial products (see page 161).

the screen. After applying thick ink to the upper edge of the screen, the printer pulls the ink evenly across the screen, using a squeegee with a rubber blade, and then back in the opposite direction, pushing the ink through the weave of the silk and onto the paper below.

The technique lends itself to flat areas of colour. Today, artists may prefer a synthetic fabric instead of silk and a frame made of metal rather than wood. The American Pop artist Andy Warhol used this technique for his prints, as in his 1968 *Campbell's Soup I: Chicken Noodle* (above).

Nicolas of Verdun
Noah and the Ark,
plaque from the
Klosterneuburg Abbey
altarpiece (*Verdun Altar*),
signed and dated 1181
Champlevé enamel on
gilded copper,
20.5 x 16.5 cm
(8 x 6½ in.)
Klosterneuburg Abbey,
near Vienna

**Enamel is often used in
combination with gold to
make jewel-like precious
items. Many art historians
consider Nicolas of
Verdun the finest
enamel artist of the
late twelfth century.
Atypically for this time,
he signed his work.**

DECORATIVE ARTS

The term decorative arts refers to items that have both aesthetic
beauty and practical purpose. Included are enamel work, stained
glass, tapestry, ceramics, jewelry and furniture.

Enamel

Enamel is coloured glass powder or paste applied to metal and fired
in a kiln or furnace at a high temperature, causing the powder or
paste to vitrify and form an opaque coating. The result is a surface
of vivid jewel-like colours polishable to a lustrous sheen. The
Egyptians used enamel embellishment at least as early as the second
millennium BCE. The technique reached a highpoint in the Middle
Ages when the two main types were cloisonné and champlevé.

The term cloisonné comes from *cloison*, French for 'cell' or
'partition', and refers to each of the small spaces formed by
soldering thin strips of gold onto a gold plaque to divide the colours.
The Byzantines probably invented the technique. A notable example
is the large *Khakhuli Triptych*, originally including 115 cloisonné

plaques made in Georgia and Constantinople between the eighth and twelfth centuries (Art Museum of Georgia, Tbilisi). The technique later gained popularity in China, although using copper or bronze rather than gold.

The term champlevé comes from the French for 'raised ground' or 'raised field'. The technique dates back to the ancient Romans and was especially popular for Christian religious items such as reliquaries and altarpieces. In contrast to cloisonné, champlevé is a western European speciality. Champlevé uses a thicker plate of copper or bronze gilded to look like gold. The artist cuts the metal with a burin or grinds it, creating recesses to receive the glass powder or paste. A fine example is the Mosan artist Nicolas of Verdun's 1181 Klosterneuburg Abbey altarpiece (previous page).

-

Soft lead strips called *cames* hold the many small pieces of glass together

-

Stained Glass

This decorative art reached its peak of popularity in medieval church windows. An early recipe for glass calls for two parts beechwood ashes (potash, an alkali) and one part river sand (silica). When heated, the alkali causes the silica to fuse, forming a greenish glass. If boiled longer it becomes yellowish or reddish, and the addition of powdered metallic oxides will produce a range of colours. Soft lead strips called *cames* hold the many small pieces of glass together (opposite).

The individual pieces of glass may be treated in a variety of ways. Grisaille, from the French for 'grey', serves to paint fine details such as facial features, fingers and fabric folds. Silverstain, known as *jaune d'argent* or 'yellow of silver', painted on glass creates vivid yellow highlights and may be applied over other colours – for example, over blue to create green. *Jean Cousin rouge* (also called sanguine or carnation), a glass paint made with iron, creates red. Certain colours, especially reds, so dark as to be almost opaque, are used as flashed glass, which is a very thin sheet of coloured glass fused to nearly clear glass or a piece of nearly clear glass dipped into the dark colour while molten. *Sgraffito* is a technique used on flashed glass in which transparent lines are scratched through the coloured film.

In the sixteenth and especially the seventeenth century, artists created a vitreous enamel – a translucent glaze – from ground glass and coloured metallic oxides for painting on glass. The result was a

Unknown artist
Early Life of Jesus, detail of lower portion of window, west façade, c.1150
Chartres Cathedral, Chartres

Stained-glass windows create an interior filled with patterns of flickering coloured light playing over the surfaces, changing with the movement of the sun and clouds. The windows at Chartres Cathedral cover c.2,600 square metres (c.28,000 square feet) and are thought to have been produced by at least two separate workshops.

fundamental change in concept from windows composed of many small pieces of glass, each a single colour, to larger pieces of very light-coloured glass onto which a variety of colours were painted.

PHOTOGRAPHY

The word photography derives from the ancient Greek meaning 'drawing with light'. Analogue photography captures images on chemically sensitized photographic plates or flexible celluloid film. The French inventor Nicéphore Niépce working with the French artist Louis Daguerre and, independently, the English inventor William Fox Talbot developed analogue photography in the 1830s. Rolls of photographic film became widely available in 1885. Film, usually manufactured in rolls of twenty-four or thirty-six images, once exposed to light in the camera, must be treated chemically in a darkroom to bring out the image that remains on the film as a negative for printing or a 'positive' for projection.

Digital photography, invented in 1975 by the American electrical engineer Steven Sasson, makes it possible to capture images using a photoelectric sensor and store them on a tiny memory chip. It is then possible to manipulate the image on a computer using software such as Photoshop, to print the photo directly from a digital printer, to project it, transmit it or store it electronically.

A digital photographer is not limited in the number of images captured at any one time because memory chips hold thousands of images. Another advantage is that the image is available for review immediately, whereas analogue film requires additional time for developing and printing. The American photographer Cindy Sherman, famous for photographing herself in many different roles (opposite), made the importance of this clear. She said, 'In the past I would shoot, say, two rolls of film, and then I'd take all my make-up off, get out of character, bring it to the lab, and then wait a couple of hours for it to be developed.' When working digitally, however, Sherman noted, 'I can start without really any idea in my mind and just be fooling around in front of the camera, take a few shots and look at them on my computer . . .'

COLLAGE

The term collage derives from *coller*, French for 'to glue' or 'to paste'. A collage is a work of art created by pasting pieces of different materials such as newspaper, photographs, fabric and random items including labels and playing cards onto a flat surface.

Cindy Sherman
Untitled #475, 2008
Chromogenic colour
print, 219.4 x 181.6 cm
(86½ x 71½ in.)

Photography, a relatively recent technique, has gradually ascended in artistic status. Although the American Sherman failed a photography course in college, she did much better when she retook it. She is the recipient of a MacArthur Fellowship, often referred to as the Genius Grant.

An example is Pablo Picasso's *Still Life with Chair Caning*, created in 1912 from oil paint, oilcloth and a rope glued to canvas (Musée Picasso, Paris).

SCULPTURE

Artists have created three-dimensional sculpture by subtractive (carving) and additive (modelling or assembling) methods since prehistoric times. The first includes solid materials such as stone, wood and ivory that have fixed dimensions within which the sculptor must work, using carving tools to remove material. The second includes substances such as wax, plaster, terracotta and plasticine clay that have no set form or dimensions, allowing the sculptor to freely change the design by both adding and subtracting material.

Stone

Good stone is consistent in texture and free of interior flaws called 'pinholes'. Marble, limestone and sandstone are all basically calcium carbonate, and thus closely related chemically and geologically, but differ in crystalline structure and, therefore, in appearance and use. Marble is hard with a smooth structure that permits the sculptor to polish it to a shine. Although usually nearly white, marble also occurs in many colours. Limestone is softer and often cream-coloured but may also be multicoloured. Polished limestone has a matte surface rather than the glossy shine of marble. Sandstone is grainy and durable, making it suitable for exterior sculpture. In contrast, alabaster, which is white or slightly tinted gypsum (calcium sulphate), has a delicate texture that makes it appropriate for the finest carving but too soft for outdoor display.

Paint and inlay may add colour to stone sculpture, as seen on the Tibetan depiction of *Dharmapala Standing on a Lion* (opposite).

Wood

Different woods vary considerably in texture, colour and grain – the finer the grain, the finer the details the sculptor may carve. Wood is subject to warping, cracking and decay and is an appetizing food for insects, yet ancient Egyptian sculptures preserved for millennia in tombs demonstrate that wood will last indefinitely if maintained under favourable conditions. Although carving stone requires greater physical strength than carving wood, greater control is needed to carve wood, as noted in woodblock printing (page 80), because wood resists the chisel inconsistently depending on whether the sculptor is cutting with or across the grain.

Unknown artist
Dharmapala Standing on a Lion, Tibet, c.16th century
Stone with traces of gold paint, inlaid with turquoise, 21.6 x 14.6 x 5.7 cm (8½ x 5¾ x 2¼ in.)
Metropolitan Museum of Art, New York

A wide range of stone types is used for sculpture, selected for colour, grain and how hard or soft the texture is. This finely carved *dharmapala* represents one of the wrathful gods who protect Buddhist law (*dharma*) and Buddhists.

Unknown artist
Minjemtimi, ancestor
figure of the Sawos
people, Papua New
Guinea, 19th century
or earlier
Wood, paint and fibre,
182.9 x 32.4 x 25.1 cm
(72 x 12¾ x 9⅞ in.)
Metropolitan Museum
of Art, New York

**Like stone, there are
many varieties of wood
having differing colours,
grains and textures that
affect the sculptor's
results. The clans of
the Sawos people of
Papua New Guinea are
associated with specific
ancestors; this life-size
statue recalls a forefather
named Minjemtimi.**

Unknown artist
Seated Ganesha, Orissa,
India, 14th–15th century
Ivory, height 18.4 cm
(7¼ in.)
Metropolitan Museum
of Art, New York

**Only elephant tusk is
true ivory. The Hindu god
Ganesha, the remover of
obstacles, is depicted as
a chubby child with an
elephant head. According
to one story, this is due to
an unfortunate accident
in which he is beheaded
by Shiva who then
replaced his original head
with that of an elephant.**

Carving a figure in accord with the grain, such as the ancestor figure
from Papua New Guinea (opposite), makes the sculptor's task easier.

Ivory
Sculptors have long considered ivory a highly desirable material.
Strictly speaking, ivory is elephant tusk, which is dentine, a vascular
calcareous material. Between the central nerve canal with its
surrounding pulp, which is too soft to carve, and the husk/bark,
too hard to carve, less than 60 per cent of the tusk is suitable for
fine carving, such as the Indian *Seated Ganesha* (above). Ivory has
a smooth feel, natural sheen and may be highly polished due to its
collagen content. However, because it absorbs moisture, salts and
other substances from the environment, ivory is not a particularly
permanent medium. The pale colour of ivory may darken or become
yellowish or brownish and is prone to staining. Ivory may warp and
crack if it becomes too dry.

Substitutes for elephant tusk include the bones of horses and cows.
They are polishable, but the spongy structure of bone makes it brittler.
Whalebone, walrus and narwhal tusks and antlers are also carvable.

Vera Manzi-Schacht
Remembrance, 2014
Terracotta, 48.3 x 45.7 x
38.1 cm (19 x 18 x 15 in.)
Collection of D'Achille-
Rosone, Little Silver, NJ

**The soft forms modelled
by hand in additive
sculptural media such
as terracotta, in which
you can almost see the
artist's fingerprints, are
unlike subtractive stone
sculptures carved with
hammer and chisel.
The American sculptor
Manzi-Schacht is a
professor of art at the
New York Institute of
Technology.**

Plaster and Terracotta

Sculptors often work in plaster and terracotta, which are soft
when modelled but harden when exposed to air to dry; in contrast,
plasticine, an oil-based clay, does not harden. Sculptures
modelled from these soft materials may require an internal
armature for support.

Among the more unusual uses of plaster for sculpture was the
creation of inedible foods by the Pop artist Claes Oldenburg, such
as his *Two Cheeseburgers with Everything (Dual Hamburgers)* made
of plaster-soaked burlap and paint (1962; Museum of Modern Art,
New York).

Terracotta ('baked earth' in Italian), a reddish-brown natural
clay, has long been used for sculpture, evidenced by the terracotta
warriors unearthed in Xi'an, China, created 210–209 BCE. After
the piece is modelled and allowed to dry until bone-hard, it is fired
in a kiln (oven) at a temperature sufficient to complete the drying

and hardening process, chemically altering the clay to make it permanent. Terracotta remains in use today as an artistic medium. The American sculptor Vera Manzi-Schacht uses it to model evocative images of great sensitivity, such as *Remembrance* (2014; opposite) incised with the poetry of Bohemian-Austrian Rainer Maria Rilke (1875–1926).

Molten metal poured into the mould replaces the wax

Metal Casting

The lost-wax technique often referred to by the French term *cire perdue*, is used to cast hollow objects. The sculptor models a heat-resistant core in the shape of the sculpture and applies a wax coating as thick as the intended metal walls. A *gating system* of wax rods (called gates or runners) is attached to the wax surface. To keep the parts in their proper relative position, the sculptor inserts metal pins through the wax and into the core, evenly distributed. The pins extend out into the investment, made of clay and sand or powdered stone, applied to form the mould. When heated, the wax coating

Unknown artist
Head of an Oba (King), Edo peoples, Court of Benin, Nigeria, 16th century
Cast brass, 23.5 x 21.9 x 22.9 cm (9¼ x 8⅝ x 9 in.) Metropolitan Museum of Art, New York

The lost-wax technique, used to cast metal sculpture, makes it possible to create finely detailed, one-of-a-kind works of art. The Edo people of Nigeria developed a highly sophisticated metal-working tradition as early as the thirteenth century, long before their first contact with Europeans.

and rods melt – the wax is 'lost' as it drains out the gates. Molten metal poured into the mould replaces the wax. After cooling, the sculptor removes the mould, core and metal pins and finishes the fine details by hand, as on the sixteenth-century *Head of an Oba* from Nigeria (previous page). Each lost-wax casting creates a single object; the sculptor must destroy the investment, therefore referred to as a waste mould, to remove it. In contrast, a piece mould, constructed in separate sections, may be removed in intact pieces and reused to cast exactly the same form again.

-

Calder's carefully balanced mobiles move with the faintest breeze, thereby changing their appearance

-

Constructions and Assemblages

In addition to carving and modelling, an artist may create sculpture by compilation – what I call 'art by amalgamation'. The Ukrainian-born American sculptor Louise Nevelson built large wall-like constructions of random pieces of wood, organized in boxes made

Alexander Calder
Untitled, c.1938
Sheet metal, wood,
aluminium, string
and paint
122 x 207 x 207 cm
(48 x 81½ x 81½ in.)
Private collection
On long-term loan to
Tate, UK

The American Calder, from a family of sculptors, worked in many media, creating everything from paintings to jewelry and sculpture. Calder invented a new type of sculpture that uses movement as an element of the composition.

of the same material, stacked up and painted a single unifying colour, usually black. Characteristic of her sculpture is the 1958 *Sky Cathedral*, huge at 340 cm (133⅞ in.) high (Museum of Modern Art, New York).

The American Alexander Calder invented a new kind of sculpture, made of separate shapes attached by wires, that hangs from the ceiling rather than stands on the floor. Calder's *Untitled* (c.1938; opposite) is an early example of kinetic sculpture in which movement is essential to the effect. Calder's carefully balanced mobiles move with the faintest breeze, thereby changing their appearance; a mobile gradually reveals its countless compositions.

KEY MEDIA

Painting and related media:
 Encaustic, fresco, mosaic, manuscript illumination, egg tempera, mixed technique, oil paint, synthetic paint (acrylic), watercolour and gouache

Prints:
 Relief, intaglio, lithography and silkscreen

Decorative arts:
 Enamel (cloisonné, champlevé) and stained glass

Photography:
 Analogue and digital

Sculpture:
 Subtractive (stone, wood and ivory), additive (wax, plaster, terracotta and plasticine clay), metal casting (lost wax), constructions and assemblages, and kinetic sculpture

BUT WHAT DOES IT MEAN?

-

I don't understand them at all. They are not literature.
They are only pictorial arrangements of images that obsess
me . . . The theories which I could make up to explain
myself and those which others elaborate in connection
with my work are nonsense . . .

-

Marc Chagall
Before 1946

The Russian-French painter Marc Chagall insisted that theories
designed to explain his seemingly symbolic images were 'nonsense'.
Although this sentiment should liberate us from feeling compelled
to explain everything we see in a work of art, our innate human
curiosity makes us want to understand what the artist is trying
to convey.

SUBJECT MATTER

Categorizing a work of art according to its subject matter may
be a useful first step in understanding its meaning. No system
of classification can be rigidly precise because, depending on
its content or theme, a work may fit into several overlapping

Opposite left:
After Praxiteles
Aphrodite of Knidos,
2nd century CE
Roman copy of a Greek
original by Praxiteles,
mid-4th century BCE
(see page 46)

Opposite right:
Michelangelo
David, 1501–4
(see page 53)

categories. Simplified, the categories that art historians have found helpful are the human figure, portraiture, mythology, religion, history, politics, genre scenes, landscape, still life and abstract art.

Artists have generated a wide range of body types, the degree of naturalism and fidelity to physical fact varying widely

Among all the subjects portrayed by artists, the human figure appears with the greatest frequency. In some instances the narrative, such as the story of Adam and Eve, requires the depiction of the nude male and female body. But other occurrences of nudes are so numerous that you might ask why artists focus so very often on the human body? Is it the innate beauty of the human form? Yes, certainly, as Praxiteles's *Aphrodite of Knidos* (opposite left) and Michelangelo's *David* (opposite right) demonstrate. However, artists are not only interested in the beautiful young body: the anatomy of the tautly muscled *David* contrasts to that of the Egyptian *Seated Scribe* (page 16), an accurate depiction of more elderly anatomy. The idealized naturalism of the *Aphrodite of Knidos* is very different from Giacometti's expressively abstracted *Woman of Venice III* (page 29 left), an inventive variation on an enduring subject. Although nature creates a wide range of body types, artists have generated a great many more, the degree of naturalism and fidelity to physical fact varying widely.

Several celebrated artists have created multiple self-portraits, akin to visual diaries recording the fluctuations in their lives

Portraiture achieved special prominence in certain cultures. Portraits that depict specific people range from precise records of every nook, cranny and crevice of the subject's facial terrain (as seen in ancient Roman stone portraits based on wax funerary masks) to recent abstract portraits in which the subject is barely recognizable as human. Portraits from Roman Egypt, such as that of a *Young Woman* (page 68), enabled her *ka* and *ba* (roughly translated as life force and soul) to recognize her mummy. Rembrandt (page 143) and Frida Kahlo (pages 151–3) are among the several celebrated artists who created multiple self-portraits, akin to visual diaries recording the fluctuations in their lives. The painting

Michelangelo
Ceiling of Sistine Chapel,
1508–12
Fresco, 40.54 x 14.02 m
(133 x 46 ft)
Vatican City, Rome

generally considered to be the most famous in the world is a portrait – of *Mona Lisa* (page 137) – painted by Leonardo da Vinci.

Subjects derived from mythology, especially those involving the Greek and Roman gods and goddesses, have long maintained their popularity with artists. While some mythological tales may alarm, others charm. Examples of the former are numerous: monstrous creatures such as the three-headed dog Cerberus or the fierce Minotaur, half-man and half-bull. More appealing perhaps are the love stories such as *Cupid and Psyche*, or *Pygmalion and Galatea*, painted by Jean-Léon Gérôme (page 120).

Religion is the impetus behind many works of art, using visual beauty to enhance spirituality and visual imagery to support doctrine. Various religions richly decorate their buildings with

Michelangelo painted the Sistine Chapel ceiling at the peak of the Italian High Renaissance for Pope Julius II. But Michelangelo did so reluctantly for he claimed painting was for women and sculpture was for men, as he demonstrated with his *David* (page 100 right), carved several years earlier.

murals, sculpture, stained glass, decorative arts and precious materials. Thus the Italian Renaissance artist Michelangelo painted nine scenes depicting events from Genesis along with prophets, sibyls, Jesus' ancestors and more on the barrel-vaulted ceiling of the Sistine Chapel (1508–12; above) in the Vatican. Pope Julius II commissioned this vast project to convey the teachings of the Roman Catholic Church. The *Creation of Adam* is the most famous scene (pages 70–71).

History paintings record actual events that may or may not be contemporaneous with the artist. Jacques-Louis David depicted the *Death of Socrates* (page 118), which occurred in 399 BCE, as well as the *Death of Marat*, his friend, in 1793 (page 119). Painted with specificity, nearly as factual as photographs, realism in historical

paintings serves to persuade the viewer that the event actually happened. History paintings often have political purposes.

-

Art and politics have been intertwined from at least the time of King Narmer of Egypt (c.3100 BCE)

-

In fact, art has long served to advance political goals. Francisco Goya created powerful anti-war paintings and prints, including *And There Is No Help* (page 81) from the *Disasters of War* series in which neither the Spanish nor the French appears heroic as Goya condemns war in general. Goya's fellow Spaniard, Pablo Picasso painted *Guernica* (pages 158–9) during the Spanish Civil War, shortly after German bombers attacked that city, as a protest against this war. Art and politics have been intertwined from at least the time of Narmer, the first king of the first Egyptian dynasty, whose accomplishments are recorded on the Narmer Palette, c.3100 BCE (Egyptian Museum, Cairo), to Shepard Fairey's *Hope* election posters (2008; opposite) in support of Barack Obama.

-

Familiar subjects, previously not considered worthy of artistic representation, gradually gained public acceptance

-

Genre scenes from ordinary daily life appeared in calendar cycles of the labours of the months, such as those in the early fifteenth-century Limbourg brothers' manuscript *Les Très Riches Heures* (*The Very Rich Hours*; Musée Condé, Chantilly, MS 65), made for Jean, Duke of Berry. Although depictions of peasant life and even middle-class activities were uncommon, they are found in sixteenth- and seventeenth-century Dutch paintings such as those by Pieter Bruegel the Elder (page 11) and Johannes Vermeer's documents of domestic activities (for example, *The Concert*, stolen from the Isabella Stewart Gardner Museum, Boston). By the late nineteenth century, genre subjects dominated French Impressionist paintings; Pierre-Auguste Renoir's *Oarsmen at Chatou* (page 39) depicts members of the bourgeoisie out boating, a popular pastime. Such familiar subjects, previously not considered worthy of artistic representation, gradually gained public acceptance.

Similarly, landscape, long treated as merely a background setting in western art, gradually became a subject that deserved

Shepard Fairey
Obama Hope, 2008
Offset lithograph,
61 x 91.4 cm (24 x 26 in.)
Obey Giant Art,
Los Angeles

The street artist and activist Fairey's powerful image, with its unambiguous and welcome message of hope, helped propel Barack Obama to become the first African-American president of the USA.

Guo Xi
Early Spring, 1072
Hanging scroll, ink and
light colour on silk,
158.3 x 108.1 cm
(62⅜ x 42½ in.)
National Palace Museum,
Taipei

**In Chinese painting,
according to the
eleventh-century court
artist Guo Xi, landscape
may be viewed from
more than one angle.
His paintings include
picturesque trees of
various kinds – old and
gnarled contrasted with
young and tall – as well
as waterways, cliffs and
rocky outcroppings,
portions implied behind
clouds.**

attention in its own right. *View from Mount Holyoke, Northampton, Massachusetts, after a Thunderstorm – The Oxbow* (page 52), painted in 1836 by the American Thomas Cole, founder of the Hudson River School of landscape painting, demonstrated this change in attitude. In contrast, landscape painting has centuries of history in China and is revered above other subjects. Guo Xi's most famous work, *Early Spring* (opposite), painted in 1072, represents a long artistic tradition.

While western landscape paintings usually have a horizontal format, Asian landscape paintings tend to favour a vertical, as with this hanging scroll on silk. The western concept of pictorial space is likely to be a continuous sweep from the foreground, through the middle ground, to the distant background, whereas Asian pictorial space leads the viewer's eyes up the picture plane, the connections between sections of the landscape often obscured by mist. Guo Xi wrote in his treatise, *Mountains and Waters*, 'The clouds and the vapours of real landscapes are not the same in the four seasons. In spring they are light and diffused, in summer rich and dense, in autumn scattered and thin, in winter dark and solitary.'

The French term for still life is *nature morte*, literally 'dead nature'

Still-life subjects, aesthetically arranged compositions of natural items (such as flowers, fruit and foods) and artificial ones (such as bottles, bowls and plates), have been popular with artists since antiquity. The French term is *nature morte*, literally 'dead nature', although not everything depicted in a still life was once alive. Rachel Ruysch's *Still Life* (page 117) includes an impressive variety of identifiable flowers. Because still-life paintings require no live models, artists may use them to work through new ideas and hone their skills. The French Post-Impressionist Paul Cézanne painted many still lifes, but he worked so very slowly (up to twenty minutes between brushstrokes) that the flowers might wilt and the fruit rot before he finished.

True abstract art does not have an identifiable subject. For example, Hilma af Klint's *Group IV, The Ten Largest, No. 3, Youth* (page 123) and Kazimir Malevich's descriptively titled painting *White on White* (page 125) are entirely non-figurative. The vexing question of the meaning of abstract art is dealt with later in this chapter (see pages 122–5).

Dieric Bouts the Elder
Last Supper, central panel
of the *Altarpiece of the
Holy Sacrament*, 1464–8
Oil on panel,
180 x 150 cm
(70⅞ x 59⅛ in.)
St Peter's Church,
Leuven

Ancient Roman muralists
used approximated linear
perspective, but it did not
continue into the Middle
Ages to any extent. Bouts
was one of the earliest
Netherlandish painters
of the Renaissance
to take advantage
of one-point linear
perspective, although
as yet neither scientific
nor consistent. He rose
to become city painter
of Louvain (now Leuven
in Belgium). Scientific
linear perspective was
highly developed in the
Renaissance.

NARRATIVE CONVENTIONS

Narrative conventions – devices employed by artists to
convey meaning visually – are essentially a form of non-verbal
communication. Such devices are especially useful for an illiterate
audience unable to read a written explanation of the subject
depicted. If used consistently and in combination, these devices
make it possible to express extremely subtle and sophisticated
ideas. Included here are linear perspective, relative size, continuous
narration, body language and iconography.

Linear perspective may be used to clarify – or confuse –
meaning in a painting. The early Netherlandish painter Dieric
Bouts the Elder's depiction of the *Last Supper* (1464–8; above)
demonstrates the use of centralized one-point linear perspective
to achieve the Renaissance goal of clarity of meaning. The major
orthogonal lines of recession of the beamed ceiling and tiled floor
recede towards a vanishing point behind the head of Jesus, thereby
leading the viewer's eyes directly to him. Thus linear perspective
simultaneously clarifies content and creates a cubic space.

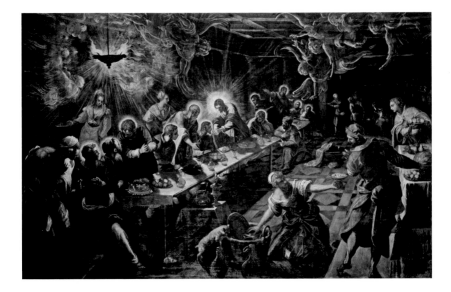

Jacopo Tintoretto
Last Supper, 1592–4
Oil on canvas,
3.65 x 5.68 m
(12 ft x 18 ft 8 in.)
Basilica of San Giorgio
Maggiore, Venice

The Italian Mannerist
Tintoretto's paintings
are characterized
by sweeping lines of
perspective leading
into depth on strong
diagonals. Although set
in an ordinary tavern, the
supernatural elements of
lamp smoke that forms
angels and Jesus' glowing
halo add drama to this
scene. Tintoretto was
nick-named Il Furioso
(The Furious) because he
painted with speed and
passion.

The importance of the location of the vanishing point becomes obvious by comparing Bouts's painting to the Venetian painter Tintoretto's of the same subject created more than a century later during the Mannerist era, in which artists intentionally obscured meaning. In his version of the *Last Supper* (1592–4; above), Tintoretto placed the vanishing point far outside the painting, thereby directing the viewer's eyes away from Jesus and making it difficult to find him in a confusing space were it not for his central location and bright halo.

Artists may use physical size to indicate a person's position in society

Relative size may effectively show the importance of one person compared to another. Used in this way, physical size does not indicate a figure's position within the pictorial space, but within the social hierarchy. In the ancient Egyptian tomb painting of *Nebamun Hunting in the Marshes* (page 27), Nabamun's large size makes clear that he is of greater importance than the other figures. Because the figure between his legs grasps his shin, her small size cannot mean she is in the distance. This straightforward, readily understood device to indicate a figure's importance appears frequently in medieval Christian art. Thus, in the *Mission of the Apostles* (page 113),

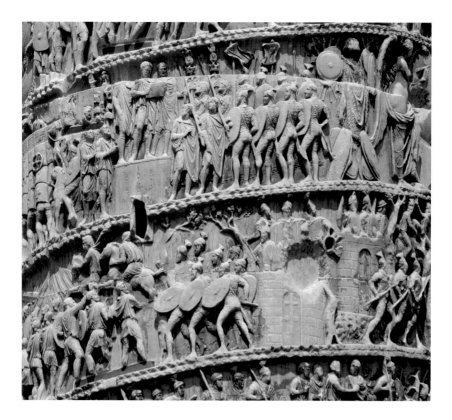

Jesus is enormous when compared to his followers. In this hierarchy of height, figures of goddesses and gods are larger than mere mortals, and religious figures are larger than queens and kings, who in turn may tower over members of lower classes.

Continuous narration is an effective device to tell a story that includes several separate events. The viewer knows these events took place sequentially, yet the artist portrays them simultaneously, without separating them into different frames. The ancient Romans used continuous narration skilfully on the Column of Trajan (107–113 CE; above) to relate the story of Emperor Trajan's military conquest of Dacia. Trajan replaced a significant portion of the Dacian population with retired Roman legionaries, creating Romania. Bands of stone relief depicting 155 scenes spiral up the column, documenting the events chronologically and in great detail.

Many years later Romanesque artists also used continuous narration to document the various events in another historically important military victory – but in a very different way. The so-called *Bayeux Tapestry* (actually embroidery on linen) depicts

Apollodorus of Damascus (?)
Detail of the Column of Trajan, 107–113 CE
Carrara marble, height 38 m (125 ft), including base c.5 m (16 ft 4¾ in.)
Trajan's Forum, Rome

The commemorative column of Trajan was followed by the Column of Marcus Aurelius in Rome, which similarly uses a spiralling band of a series of sequential scenes carved in relief to document a military victory.

110

seventy scenes from the 1066 invasion of England by Duke William of Normandy, known thereafter as William the Conqueror.

The story is told using nonverbal communication

Unknown artist
Adam and Eve Reproached by God, one of 16 door panels, c.1015
Bronze relief, c.58.3 x 109.3 cm (c.23 x 43 in.)
St Mary's Cathedral, Hildesheim

Because only a small portion of the population was literate at this time, clear narrative representation was essential in storytelling. This relief demonstrates that an image may convey a message more effectively and in a more memorable manner than a written description.

Body language, communication using physical gestures and postures rather than words, may tell a story effectively. Among the most straightforward examples is *Adam and Eve Reproached by God* (c.1015; below), one of the biblical scenes from Genesis depicted in relief on the bronze doors commissioned by the Ottonian Bishop Bernward in the early eleventh century, now at St Mary's Cathedral in Hildesheim.

God leans forward and points an accusatory finger at Adam and Eve, who crouch submissively before him. Adam, having eaten the forbidden fruit from the tree of knowledge and therefore aware of his nakedness, covers himself with one hand and points to Eve with the other, passing the blame to her. Eve, in turn, covers herself with one hand and points with the other to the serpent who tempted them, also passing the blame. Thus, the story is told using nonverbal communication. Neither Adam nor Eve takes responsibility for their own actions, indicating that this aspect of human nature has a long history.

ICONOGRAPHY – THE LANGUAGE OF SYMBOLS

Religious art in particular often makes use of symbols. The image of a fish (above) served as a secret symbol for early Christians hoping to avoid persecution. The ancient Greek word for 'fish', *ichthys* (or *ichthus*), is an acrostic for, in English translation, 'Jesus Christ, God's Son, Saviour'. A simplified image of a fish discreetly marked Christian buildings and believers, making them recognizable only to those who knew the significance of the symbol.

Iconography makes it possible for artists to transmit multilayered messages. At the Romanesque church of Sainte-Marie-Madeleine in Vézelay, the entrance hall tympanum is carved with a depiction of the *Mission of the Apostles* (1120–32; opposite) to spread the doctrines of Jesus at all times of the year and throughout the world. How can even the cleverest of carvers convey this idea without words? The rays extending from Jesus' fingertips to the head of each apostle indicate that his ideas enter their minds for them to disseminate. The signs of the zodiac in the archivolt bordering the tympanum make clear that their mission extends throughout the

Unknown artist
Ichthys, Christian fish symbol, early Christian funerary stele from the Vatican cemetery, Rome, early 3rd century CE
Marble, 30.5 x 33.2 x 6.7 cm (12⅛ x 13⅛ x 2¾ in.)
Museo Nazionale Romano, Terme di Diocleziano, Rome

Iconography, the language of symbols, uses things such as items, shapes, colours, numbers, animals and plants to represent ideas. Although the Edict of Milan in 313 CE ended the persecution of Christians in the Roman empire, the fish remains a symbol of Christianity to this day.

year. The apostles must preach to all the known world, even to those imagined races depicted on the inner archivolt and the lintel, including dog-headed people who communicate by barking and the Panotti whose ears are so large they serve as blankets if the owner is cold or as the equivalent of wings to fly away if frightened.

Narrative conventions make it possible to convey extremely subtle and sophisticated ideas

Unknown artist
Mission of the Apostles,
tympanum, 1120–32
Limestone relief, width
9.25 m (30 ft 4 in.)
Sainte-Marie-Madeleine,
Vézelay

In this complex French Romanesque tympanum, several narrative devices, such as the use of iconographic symbols and relative size of the figures, are combined. The result is a didactic image that is effective in instructing the faithful while simultaneously decoratively embellishing the church.

The meaning of certain symbols is well known or easily deduced from context. For example, the apple is a common symbol of evil in Christian art because it is the fruit God forbade Adam and Eve to eat in the Garden of Eden, and because in Latin, the language of the Christian Church, *malum* means both 'evil' and 'apple'. Remnants of early iconography remain with us today. For example, the dog has been a symbol of faithfulness since antiquity – in Latin *fidus* or *fides* mean faithful, hence Fido, 'man's (and women's) best friend'. The idiom 'busy as a bee' also goes back to antiquity. A person may be described as 'shy as a violet', a medieval symbol of humility. Today the English language even uses fruits as descriptors – favourably when we say 'he's the apple of my eye' or 'she got a plum job', but unfavourably if we say 'that old car is a lemon'.

CONFLICTING MEANINGS

The meaning of a person, animal, object, colour or number is often inconsistent and, further complicating the matter, the multiple meanings may even conflict, as in the case of the apple just mentioned as carrying both negative and positive connotations. The key to deciphering iconography is the specific context in which a symbol appears.

Different cultures may interpret an animal, especially an imaginary one, with wide-ranging meaning. Dragons in western

114

Unknown artist
Dragon Robe, 18th
century, Qing dynasty,
China
Silk, 139.7 x 170.2 cm
(55 x 67 in.)
Metropolitan Museum
of Art, New York

One symbol may convey
different meanings
depending on the context
in which it appears.
Although the dragon
represents the devil
and evil in western
cultures, in Asian
cultures the dragon is
a good creature that
symbolizes positive
qualities such as
wisdom, strength and
luck. The emperor of
China is represented
by the dragon.

cultures are malevolent creatures, associated with the serpent who
tempted Adam and Eve. Symbols of evil, dragons destroy with their
fiery breath and attempt to devour fair maidens. Thus St George
must rescue Princess Cleodolinda from a dragon. But in Asia, the
dragon has been regarded as a good creature for millennia and is the
symbol of the Chinese emperor.

**The number of claws a dragon possesses is a
symbol of status; the more claws, the higher the status,
five being the maximum number**

A benevolent animal who brings good luck, the dragon is
the mythical ancestor of the Chinese people. Several dragons,
typically long and limber, adorn the eighteenth-century festival
robe seen opposite. The number of claws a dragon possesses is a
symbol of status; the more claws, the higher the status, five being
the maximum number of claws per paw and signifying the Son
of Heaven or the emperor. The five-clawed dragons on this robe
indicate it was worn by a member of the imperial family. Dragons
of lower status may have only four or a mere three claws per paw.

Even within a single culture, symbols may have multiple and
conflicting meanings. The lion, the animal depicted most frequently
in western European medieval art, can be a symbol of Jesus.
The medieval Bestiary (Book of Beasts), a small encyclopaedic
compilation of animal lore especially popular in twelfth-century
France and England, explains that lions are born dead, but revived
three days later by their father, just as God brought Christ back to
life three days after his death. Because the people of the Middle
Ages believed lions slept with their eyes open, images of lions served
as guardians at entrances and tombs. In heraldry, lions indicate
military might and courage. In each of these examples the lion
is a positive symbol.

However, the lion also appears repeatedly as an emblem of evil
in the Bible. Psalm 7:2 reads, 'They will tear me apart like a lion and
rip me to pieces,' and Psalm 22:21 says, 'Rescue me from the mouth
of the lions.' The story of Daniel, spared from the lions by God
(Daniel 6:22), was depicted in medieval art, for example, carved on
a late twelfth/early thirteenth-century capital from the cloister of
Saint-Guilhem-le-Désert, France (The Cloisters, New York). Thus
the same culture, during the same period, attributed contradictory
iconographic connotations to this animal.

Hieronymus Bosch
Garden of Earthly Delights,
detail of right panel,
1490–1500
Oil on oak panel, overall
dimensions of triptych,
2.06 x 3.85 m
(6 ft 9 in. x 12 ft 8 in.)
Museo Nacional del
Prado, Madrid

**Bosch cleverly criticized
a Church practice when
he depicted a pig in
nun's clothing coercing
a dying man to sign over
his wealth to the Church.
Animals continue to play
such roles even today, for
the anonymous British
street artist known as
Banksy (page 17) often
uses images of rats.**

SUBTLE SYMBOLISM

Iconography may be subtle in presentation yet powerful in
meaning, with symbols used to mask a message. In the
Netherlandish Renaissance painter Hieronymus Bosch's triptych
known as the *Garden of Earthly Delights* (1490–1500), much of
the complex symbolism remains open to debate. However, the
meaning of the pig embracing a man (above) in the lower right
corner of the right panel is unambiguous. A porcine predator,
dressed in the habit of a Roman Catholic nun, embraces a dying
man – indicated by his nakedness. She dips the quill pen into the
inkwell offered by a monstrous creature. Bosch refers here to
death-bed wills (draped over the man's left thigh) made under
duress which benefit the Church. Substituting a pig for a person
camouflages Bosch's criticism of this Church practice, making it
both humorous and more memorable, while enabling him to avoid
personal repercussions.

A different type of understated symbolism appears in certain
floral still-life paintings where surface beauty masks an ominous
moralizing message. A *vanitas* painting (Latin for 'vanity'), like a
memento mori painting (Latin for 'remember you must die'), reminds
people that death is unavoidable. Some of the symbols, such as
a skull, are obvious. But other symbols of life's brevity are less
straightforward, such as a candle burning low or an hourglass with
the sands of time running out.

Rachel Ruysch
*Still Life of Roses, Tulips,
a Sunflower and Other
Flowers in a Glass Vase
with a Bee, Butterfly and
Other Insects upon a
Marble Ledge*, 1710
Oil on canvas,
88.9 x 71.1 cm
(35 x 27⅞ in.)
Private collection

**Ruysch was one of a
number of flower painters
working in Holland
during the eighteenth
century, but she became
internationally known for
her meticulous, symbol-
laden still lifes. Remnants
of seventeenth- and
eighteenth-century
flower symbolism remain
with us today. Thus roses
are widely understood to
imply love and romance,
but chrysanthemums are
associated with funerals
and death.**

Subtler still are depictions of once beautiful flowers and luscious fruit now wilting, rotting or eaten by insects, references to our inevitable bodily decay. *Memento mori* flower still-life paintings were especially popular in the seventeenth- and eighteenth-century Netherlands, such as those by the Dutch Baroque painter Rachel Ruysch (1710; below) that depict an impressive variety of flowers and insects. The short-lived beauty of the flowers implies the transience of earthy pleasures and thus their ultimate unimportance. *Vanitas* and *memento mori* images remind the viewer to repent their misdeeds and sins and to live better lives while they still can.

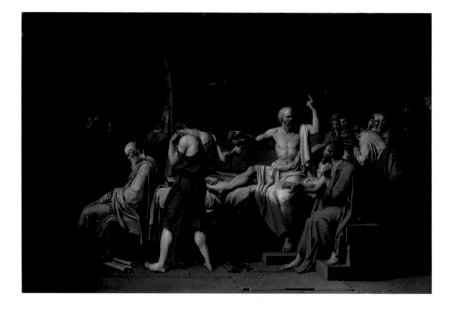

SOMETIMES YOU REALLY NEED TO KNOW THE STORY

In certain works of art, the artist's intent may elude a viewer unfamiliar with the specific story depicted. This is true especially when the portrayal of an actual historical event conveys a moralizing message. A reaction to the light-hearted hedonist pleasures of Rococo paintings appears in the Neoclassical paintings created in the second half of the eighteenth and first half of the nineteenth century, now concerned with high moral rigour.

Ethical issues underlie the French Neoclassical artist Jacques-Louis David's *Death of Socrates* (1787; above). Given the choice of renouncing his beliefs or death by poison, the ancient Greek philosopher chose the latter, committing suicide by drinking hemlock in prison in 399 BCE. Socrates points upward, a reference to the soul's immortality. His student Plato, who was not actually present but related the story in his *Phaedo* (also known as *On the Soul*, a dialogue on the immortality of the soul), sits at the foot of the bed.

David also documented contemporaneous events such as the *Death of Marat* (opposite), painted in 1793, the year of his friend Jean-Paul Marat's murder. Charlotte Corday stabbed Marat, a leader of the French Revolution, in the chest while he was in his bath; he still grasps the letter she wrote and delivered. Corday sided with the moderate Girondins, ousted by the radical Jacobin Marat. Corday would die by guillotine for murdering Marat. The names

Jacques-Louis David
Death of Socrates, 1787
Oil on canvas,
129.5 x 196.2 cm
(51 x 77¼ in.)
Metropolitan Museum
of Art, New York

David and other Neoclassical artists looked back to antiquity for stories that convey ethical concepts. His *Death of Socrates* glorifies the Greek philosopher who dies for his principles, and his painting of the ancient Roman story *The Oath of the Horatii* (1784; Louvre, Paris) advocates putting country above family.

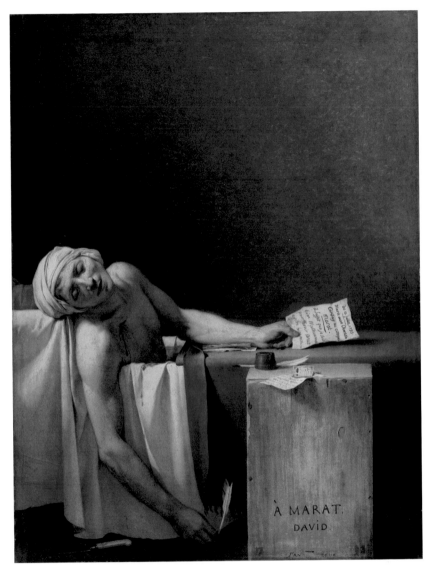

Jacques-Louis David
Death of Marat, 1793
Oil on canvas,
165 x 128 cm
(65 x 50 in.)
Royal Museums of Fine
Arts of Belgium, Brussels

David used his artistic
skills in the service
of his political views,
both as morality tales
and as documentation.
Enmeshed in the politics
of his era, David was
among the leaders of
the French Revolution.

A Jacobin, he was jailed
for his political activities.
He would become painter
to Napoleon.

Marat and Corday are both included in the painting, but a viewer who knows who these people were and what happened here can appreciate the painting on a deeper level.

Other works of art where the viewer needs prior knowledge of the subject portrayed are very different. For instance, why is a man kissing a statue in the French artist Jean-Léon Gérôme's painting *Pygmalion and Galatea* (c.1890; above)? This story from ancient

Jean-Léon Gérôme
Pygmalion and Galatea,
c.1890
Oil on canvas, 88.9 x
68.6 cm (35 x 27 in.)
Metropolitan Museum
of Art, New York

The story of Pygmalion and Galatea depicted by the French artist Gérôme is one of many ancient myths given visual form. Particularly popular are the Labours of Hercules, the Judgement of Paris, and Apollo and Daphne.

Greece, recorded by the Roman poet Ovid in his *Metamorphoses*, tells of the sculptor Pygmalion who carves a figure of a beautiful woman. So enthralled is he with this ideal woman that he asks Aphrodite, goddess of love, for such a woman to be his wife. When he returns home and kisses the statue, she comes to life and returns his affection.

In another example, neither historical nor mythological but literary, the Spanish artist Pablo Picasso illustrated the story of *Don Quixote of La Mancha* (below), the novel written by the seventeenth-century Spanish author Miguel de Cervantes. The gentleman Don Quixote, inspired by reading stories of chivalry, goes forth, lance in hand, on adventures with his sidekick Sancho Panza. In accord with Cervantes's description, in 1955 Picasso depicted Don Quixote as tall and slender (on his correspondingly

Pablo Picasso
*Don Quixote and
Sancho Panza,* 1955
India ink drawing on
paper, dimensions of
original unknown
Location of original
unknown

With a simple ink drawing, without the aid of colour, the Spanish artist Picasso conveys a sense of the characters, their relationship and the story of *Don Quixote of La Mancha*. Picasso is discussed in the following chapter.

skinny horse), while Sancho Panza (Spanish for 'belly') is small and round (on his correspondingly bulbous donkey). In the background Picasso included the windmills towards which Don Quixote tilts, believing they are giants.

ABSTRACT ART

Because it is non-figurative and non-representational, with no readily identifiable subject, some people consider abstract art a purer art form than representational art. But if there is no recognizable subject, is there meaning? And if there is meaning, who provides it – the artist or the viewer? Abstract art encourages a more active role on the part of the viewer than representational art – indeed, artist and viewer collaborate. The viewer's role in interpreting non-representational art is personal and cerebral, for without definite clues from the artist, each individual's understanding of the artwork will vary. The viewer must make an effort to arrive at an interpretation and may therefore get more out of participating in the process than by being a passive, unquestioning observer. Abstract art appeals to our emotions, memories and experiences – what is deeply moving for one person may be meaningless to another.

How do you feel about works of art titled *Untitled*? Or those that have nothing more than a number or a list of colours to identify them? Should the artist give the viewer at least a hint as to what his or her intentions were in creating this work of art?

Af Klint was the earliest painter of truly abstract art

The Russian painter Vasily Kandinsky had been considered the founder of abstract art due to paintings he made in 1910–11. The earliest completely abstract works are now, however, believed to be those created by the Swedish mystic Hilma af Klint. Although she painted portraits and landscapes in a naturalistic and highly representational style, during the same period and unknown to the public, she painted in an entirely abstract style at least as early as 1906. Other artists whose work includes early abstract paintings are the Russian Kazimir Malevich and the American Georgia O'Keeffe. But af Klint appears to have been unconnected with these artists who arrived at abstraction as the result of a gradual simplification of the outer visual world.

Hilma af Klint
Group IV, The Ten Largest, No. 3, Youth, 1907
Tempera on paper mounted on canvas, 3.21 x 2.4 m (10 ft 6⅜ in. x 7 ft 10½ in.)
The Hilma af Klint Foundation, Stockholm

Af Klint's paintings translate the spiritual messages she received into a visual language, using abstraction to make the invisible spiritual world visible. Af Klint favoured geometric shapes, some akin to diagrams, with spirals recurring and unifying the compositions, all forms painted with precision.

In contrast, af Klint created her form of abstract art fully developed and as a response to the inner spirits she said guided her. While participating in a séance in 1904, she came to believe that the 'High Masters' assigned her the job of producing what she called *The Paintings for the Temple*; she created 193 abstract *Temple* paintings between 1906 and 1915. The very large paintings made in 1907, known as *The Ten Largest* (previous page), are concerned with the cycle of life.

Believing the public was not yet ready for her non-figurative paintings, and because the 'High Ones' told her neither to exhibit her paintings nor to show them to others, her will stated that their exhibition must wait until long after her death. When she died in 1944, more than 1,200 abstract paintings were stored in her studio in boxes that remained unopened until the late 1960s. The first public exhibition of her paintings took place in 1986 at the Los Angeles County Museum of Art. She subsequently received recognition for her achievement as, presumably, the earliest painter of truly abstract art.

Kazimir Malevich
Suprematist Composition:
White on White, 1918
Oil on canvas,
79.4 x 79.4 cm
(31¼ x 31¼ in.)
Museum of Modern Art,
New York

The Russian Suprematist Malevich pared down his painting to the minimum colour and shape essential to be considered a painting. He said, 'By "Suprematism" I mean the supremacy of pure feeling in creative art.'

-
Malevich linked white with timelessness and infinity because it has no resemblance to any recognizable subject
-

The popularity of abstract art depends on the fact that, even without an identifiable subject, it is possible to convey and elicit emotion through the artist's use of the visual elements (pages 36–65). Art has the ability to suggest happiness, sadness, agitation, calm and a range of other human emotions without the use of imagery. Perhaps this is comparable to the manner in which music can evoke emotions without the use of words.

If even the simplest shapes and colours can convey meaning, how simple might a painting be? It would be difficult to make a painting less complicated than Kazimir Malevich's 1918 *White on White* (opposite), from his series of white-on-white paintings. This Russian artist of the Suprematist movement associated the white square with a feeling of floating. He linked white with timelessness and infinity because it has no resemblance to any recognizable subject, and therefore time or place or earlier artistic style.

Your interpretation of abstract art, because it is individual and your own, is as important and valid as that of anyone else. Abstract art exercises your imagination, for as Leonardo da Vinci recommended, 'look into the stains of walls, or the ashes of a fire,

or clouds, or mud or like places, in which, if you consider them well, you may find really marvellous ideas . . . because by indistinct things the mind is stimulated to new inventions'.

FACT VERSUS OPINION

While art exercises the imagination, please try to avoid unsubstantiated speculation in your interpretation. Art-historical writing, unfortunately, includes 'fake news' in which an authoritative writer or speaker presents a personal opinion as if it were irrefutable documented fact. But scepticism is prudent when corroborating information, photographic evidence or written records are lacking. Not surprisingly, this problem is especially evident when discussing abstract art.

Unknown artist
Woman of Willendorf,
c.28,000–25,000 BCE
Oolitic limestone with
red ochre pigment,
height 11.1 cm (4⅜ in.)
Naturhistorisches
Museum, Vienna

**This stone figurine has
been called a fertility
symbol, a mother
goddess, an anatomical
ideal, a self-portrait, an
aphrodisiac, a good luck
charm and more. That
this figurine 'embodies'
an idea is supported by
the lack of facial features
that would imply the
depiction of a specific
individual. But, without
written documentation,
the only reliable source
of information about
prehistoric art is the
art itself.**

The problem occurs throughout the history of art. When seeking meaning in prehistoric art, there are no documents to clarify the original intention of the artist. Only educated guesses based on comparisons to related works are possible. Nevertheless, the little prehistoric sculpture of a bulbous nude woman, carved c.28,000–25,000 BCE, is often referred to as the *Venus of Willendorf* (above). Yes, she comes from Willendorf in Austria. But is there any reason to call her Venus, after the Roman goddess of love? Some people suggest she is pregnant and therefore a fertility symbol, but her anatomy is not that of a pregnant woman in which the navel stretches flat or protrudes rather than indenting. Instead, is this an image of obesity as the ideal at a time when food was scarce? Her meaning, if one were intended, remains an unanswered question. The moral of this story is: try to resist the tendency to impose ideas current in your own culture today on earlier or foreign cultures.

The ultimate authority on the artist's intended meaning of a work of art is, of course, the artist who created it. Consider Kay WalkingStick, a member of the Cherokee Nation of Oklahoma and a pioneer in the arts for Native Americans. She created a

series of landscape diptychs, including *Oh, Canada!* (pages 128–9), 2018–19. For WalkingStick, art is a way to understand nature and, as she expressed it, to 'honour the earth'. In *Oh, Canada!*, WalkingStick paints the beauty of the vast and unspoiled rocky landscape of Mount Rundle, Banff National Park, Alberta. In regard to the diptych format, she explained, 'I do not see my paintings as landscapes, per se, but rather as paintings that describe two kinds of perception of the earth. One view is visual and fleeting and the other is abstract and everlasting.' Through abstraction, WalkingStick seeks the simplest way of expressing a deep thought. She said, 'I expect of abstraction as much as what imagery does for me . . . to carry meaning . . .' Concerned with the history of Native Americans, WalkingStick included the pattern of Native American symbols for their connection to the Stoney Nakoda people who still live on this land, and as a reminder that this was all Native land. She emphasized, 'We're all different and we're all the same.'

KEY IDEAS

Categories of subject matter:
 Human figure
 Portraiture
 Mythology
 Religion
 History and politics
 Genre scenes
 Landscape
 Still life
 Abstract art
Narrative conventions:
 Linear perspective
 Relative size
 Continuous narration
 Body language
Iconography – the language of symbols:
 Conflicting meaning
 Subtle symbolism
 Vanitas and *memento mori* paintings
Abstract art:
 Hilma af Klint
 Validity of each viewer's personal opinion
Fact versus opinion:
 Avoiding unsubstantiated speculation

Kay WalkingStick
Oh, Canada!, 2018–19
Oil on wood panel,
91.4 x 182.9 cm
(36 x 72 in.)
Collection of the artist

The Native American
artist WalkingStick's own
words are the most direct
route to understanding
her work. As is true for
other artists as well,
the analyses written by
even the most astute
critic or art historian risk
introducing biases or
misinformation, which
becomes increasingly
more likely the further
removed we are from the
creation of the work.

SIX SPECIAL ARTISTS

-

Greatness in the arts is born in some from diligence,
in another from study, in this one through imitation,
in that one from knowledge of science . . .
others use all these things together or most of them

-

Giorgio Vasari
1568

Certain artists have had especially notable influence on the history of art. This chapter offers an overview of the lives and works of six artists – chosen from many candidates. Some artists rise to a level of great significance during their own lifetime, but for the majority, sadly, it is only after their death that the public recognizes their importance, even genius. These six innovative artists span the centuries from the late fifteenth to the late twentieth, and represent Italy, Holland, France, Mexico, Spain and the United States. They are Leonardo da Vinci, Rembrandt van Rijn, Vincent van Gogh, Frida Kahlo, Pablo Picasso and Andy Warhol.

LEONARDO DA VINCI (1452–1519)

Leonardo da Vinci, born in Vinci near Florence, was the exemplar of what we today call 'a Renaissance man'. This polymath, most famous as a painter, was also a sculptor, architect, engineer, anatomist, biologist, geologist, geographer, inventor, set designer and party planner.

Leonardo developed two new methods of painting: *chiaroscuro* and *sfumato*. *Chiaroscuro*, derived from the combined Italian words for 'light' and 'dark' or 'clear' and 'obscure', involves the use of areas of light and shadow. Light subtly emphasizes what the artist wants the viewer to see, while shadows mask all else. In *sfumato*, derived from the Italian for 'smoke', the outlines of the various forms soften and blend with the background, creating a slightly hazy effect that suggests the surrounding atmosphere.

Science and Art Unite in Renaissance Italy

Leonardo's innovative approach, combining science and art, appears in his painting of the *Virgin of the Rocks* (1483–6; opposite). The results of his research are evident in the identifiable plants and the realistic representation of the grotto's stalagmites and stalactites. This novel depiction of Mary and Jesus in a grotto suggests the idea of the womb of the earth where Mary is a mother goddess. She protects the future John the Baptist, taking him under her cloak. John represents the Christian congregation, protected by Mary and blessed by Jesus.

Beauty in art, according to Leonardo, is obtainable through geometry, arithmetic, perspective and scientific observation. These ideas appear in his depiction of the *Last Supper* (pages 134–5), a huge mural painted between 1495 and 1498 in the refectory of the Convent of Santa Maria delle Grazie, Milan.

The composition makes Jesus the focus. By drawing the room where the Last Supper takes place in centralized, one-point

Leonardo da Vinci
Virgin of the Rocks,
1483–6
Oil on panel (transferred to canvas), 199 x 122 cm
(78⅜ x 48 in.)
Musée du Louvre, Paris

Leonardo da Vinci was probably the most scientific artist of his era. Among the first Renaissance artists to dissect corpses, Leonardo made detailed drawings of the various parts of the body and their functions.

perspective with all diagonal lines of recession converging toward Jesus, Leonardo leads the viewer's eyes to him. Jesus is in the centre of the almost bilaterally symmetrical composition and his upper body forms an equilateral triangle, a geometric shape favoured during the Renaissance for its stability. The largest of the three windows on the back wall is directly behind Jesus, framing and emphasizing him. The segmental pediment above this window subtly replaces the halo he wore in earlier paintings. The twelve apostles are arranged six on each side, neatly divided into four groups of three figures. Light enters from the windows on the back wall as well as from the left, placing the side with the traitor, Judas, in shadow.

Leonardo da Vinci
Last Supper, 1495–8
Combined painting
media, 4.6 x 8.79 m
(15 ft 1 in. x 28 ft 10 in.)
Refectory, Convent
of Santa Maria delle
Grazie, Milan

Leonardo distinguished between different kinds of light, writing, 'The lights which may illuminate opaque bodies are of four kinds ... diffused light as that of the atmosphere ... direct, as that of the sun ... reflected light, and ... that which passes through [semi] transparent bodies, as linen or paper, or the like ...'

With this painting, Leonardo may have had the last word on the Last Supper.

Leonardo experimented constantly, but the results were not always successful. The ruined condition of the *Last Supper* mural is due to the untested method he used: rather than the customary *buon fresco* technique of painting on wet lime plaster, he painted on dry plaster with a combination of oil and tempera. The paint did not adhere well and actually began to deteriorate while he was working on it. The *Last Supper* has undergone conservation and restoration several times, the most recent team of experts completing their work in 1999.

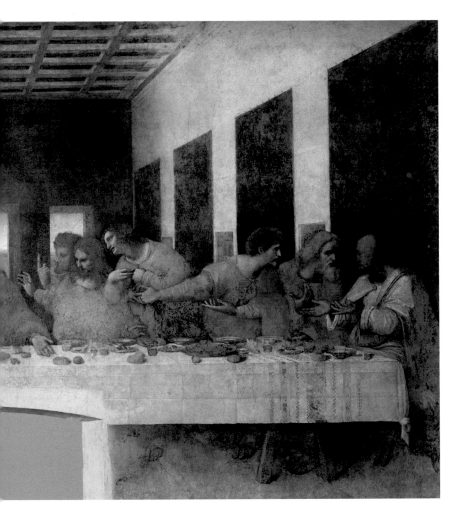

Interest in the individual is a characteristic of the Renaissance, given visual form by artists in portraits and self-portraits, and literary form by writers in biographies and autobiographies. The most famous example of Renaissance portraiture, indeed the most famous painting in the world, is that of *Mona Lisa* (c.1503–19; opposite), painted by Leonardo da Vinci. *Mona* is a contraction of Madonna, meaning 'my lady'. The sitter was the Florentine noblewoman Lisa di Antonio Maria Gherardini, born in 1479 and married at the age of fifteen to the rising Florentine bureaucrat Francesco del Giocondo, then twenty-nine. Consequently this painting of his third wife is also known as *La Gioconda*. It is debatable whether the landscape background depicts a real location.

Leonardo da Vinci
Mona Lisa (Lisa Gherardini), c.1503–19
Oil on poplar panel,
77 x 53 cm (30 x 21 in.)
Musée du Louvre, Paris

In the fashion of the time, Lisa Gherardini's high plucked and shaved forehead indicates her nobility, the absence of eyebrows enhancing the effect. In addition to the physical appearance of his sitters, their emotional state was of interest to Leonardo. Mona Lisa's enigmatic smile leads the viewer to wonder what she was thinking (and, especially, feeling) while she posed for Leonardo.

-
The fame of *Mona Lisa* derives from the puzzling facial expression
-

Breaking with the rigid, bust-length, profile portraits of the Early Renaissance, Leonardo's portrait of *Mona Lisa* established a new way of presenting an individual. His sitter appears in a half-length, three-quarter view, hands included, seemingly relaxed and natural. *Mona Lisa* popularized this type of portrait format, which would be used repeatedly during the High Renaissance and later.

The fame of *Mona Lisa* derives from the puzzle presented by the ambiguity of her facial expression. Does she smile, or is she sad? Leonardo was concerned not only with the sitter's exterior, but also with the interior, the psychological subtleties of individual personalities. Similarly, when he dissected cadavers, he was interested in not only the appearance of the internal organs but also the function of each.

Leonardo da Vinci left posterity countless pages of illustrated notes, written right to left, using his left hand. Included are designs for his many inventions, biological and botanical observations and architectural designs (never built) based on geometric shapes. He died in his little château, the Clos Lucé, in Amboise, which he had received as a gift from his host, the French king François I.

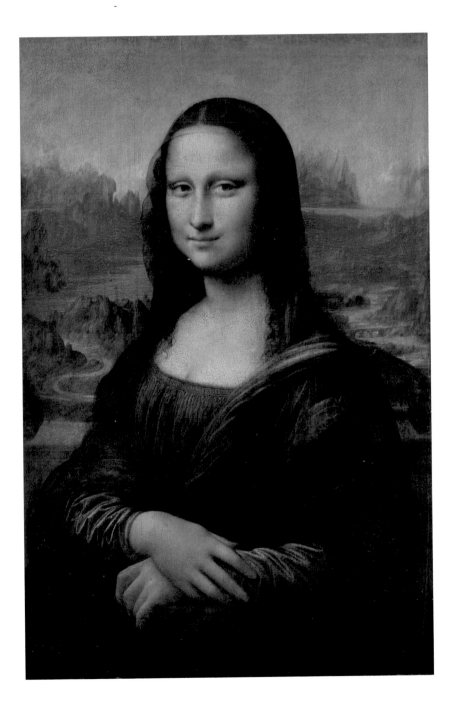

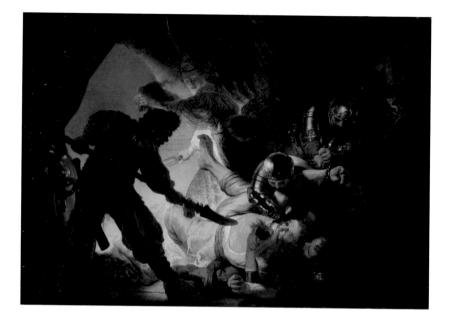

REMBRANDT VAN RIJN (1606–69)

Rembrandt van Rijn, born in Leiden, is without doubt the most famous painter of the Baroque era in Holland. He abandoned his study of classical literature at the University of Leiden, preferring instead to study painting. His first group portrait, *Doctor Tulp's Anatomy Lesson* (1632; Mauritshuis, The Hague) made him the most popular painter in Amsterdam. In 1634 he married Saskia van Ulenborch, who brought him great joy, was often his model, and came from a wealthy family. Now very happily married, and the recipient of many commissions, the affluent Rembrandt owned a large house and art collection in Amsterdam.

The Golden Age of Dutch Baroque Art

Rembrandt's painting of the *Blinding of Samson* (1636; above) demonstrates the artistic style that accounts for his success. The dramatic moment selected for depiction as well as the dynamic diagonals that enhance the emotional tension are in perfect accord with the Dutch Baroque tastes of the time. Rembrandt, called 'the lord of light', emphasizes striking light effects. *Chiaroscuro* if taken to an extreme with exaggerated contrasts of light and dark becomes tenebrism (from *tenebroso*, meaning 'dark' in Italian), in which a strong light intensifies the centre of interest, emphasizes expressive features and banishes unimportant details to the shadows. The light,

Rembrandt
The Blinding of Samson, 1636
Oil on canvas, 219.3 x 305 cm (86⅜ x 120⅛ in.)
Städel Museum, Frankfurt am Main

Rembrandt was drawn to the drama of Old Testament events. Here he portrays the most horrific part of this story as Samson's hair (the source of his strength) is cut off and his eyes are gouged out.

while serving multiple purposes, is non-naturalistic and inconsistent. Yet all Rembrandt's paintings balance perfectly in terms of light and dark (which you may test by squinting your eyes).

Saskia's early death in 1642, leaving Rembrandt with their infant son Titus, was the turning point in the artist's life. In this year he painted the famous *Night Watch* (pages 140–41), but his popularity as an artist started to decline, because his style became more personal – and less easily understood by his patrons. His financial difficulties began.

Rather than giving each person equal prominence, Rembrandt emphasized Baroque dramatic lighting and diagonal movements

The Night Watch is a huge group portrait of a military organization – a civic guard of Amsterdam. All the men portrayed had contributed equally to the cost, making the issue of equal representation in the painting crucial. But Captain Frans Banninck Cocq and his lieutenant, Willem van Ruytenburch, received the greatest emphasis, leaving the other participants – some portrayed by little more than their noses emerging from the dark Baroque lighting – feeling cheated. Rembrandt was more concerned with creating a Baroque composition of action moving on diagonals, thereby avoiding the usual problem of rigid rows of faces in group portraits. Originally, the captain and lieutenant were portrayed just one step away from the centre of the composition. This clever device to imply movement, which Giotto had used many years earlier (page 55), was effective until the trimming of the painting on all sides, especially on the left.

The painting shows the members of this company coming through Amsterdam's city gate in the morning to welcome Marie de' Medici, queen of France. Debate over the identity of the richly attired girl in the crowd continues; she may represent the Kloveniers Militia and carries emblems of this civic guard, including the chicken, its claws a reference to *clauweniers*, and a drinking goblet.

Rembrandt collected works of art and other objects, using some of them as props in his paintings. But he had extravagant tastes and bought compulsively, even when he could no longer afford to do so. He eventually owned approximately sixty casts of antique statues and about 8,000 prints and drawings, including works by Raphael, Michelangelo, Titian, Lucas van Leyden, Dürer, Holbein and Rubens.

Rembrandt
The Night Watch, Militia
Company of District II
under the Command of
Captain Frans Banninck
Cocq, 1642
Oil on canvas,
37.95 x 45.35 m
(12 ft 6 in. x 14 ft 10 in.)
Rijksmuseum,
Amsterdam

Rembrandt's painting
acquired the nickname
of the 'Night Watch' in
the eighteenth century
when it had darkened
and, in spite of cleaning,
it remains very dark. The
event depicted actually
occurred in the morning.

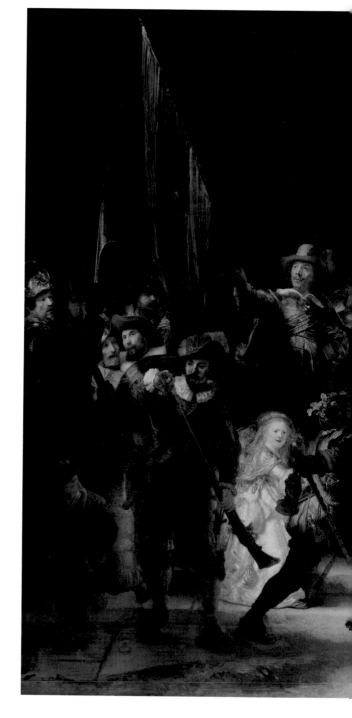

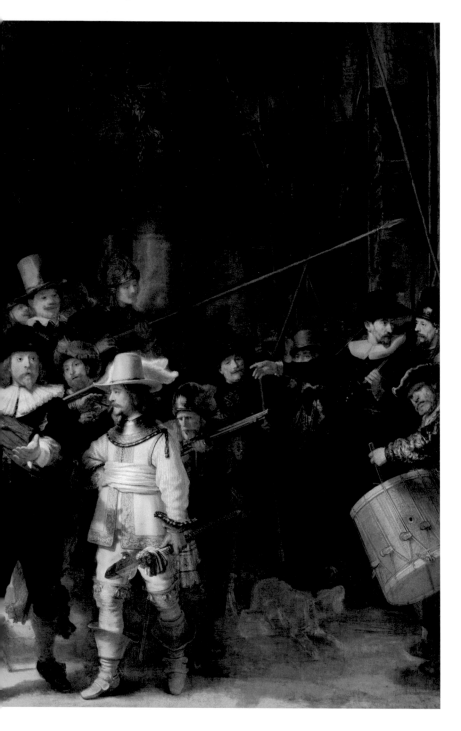

His collecting, coupled with his inability to manage money and declining income, resulted in financial disaster. In 1656 Rembrandt declared himself bankrupt.

Rembrandt's style became progressively more introverted

There were other troubles. Geertje Dircx, originally hired as a wetnurse for Titus, became Rembrandt's lover. But the relationship soured and ended with a court case in which she claimed he had breached his promise of marriage. She was imprisoned and, after her release, tried to sue Rembrandt. His affections had shifted to his housekeeper, Hendrickje Stoffels, who became his model, mistress and stepmother to Titus. Stoffels gave birth to a daughter, Cornelia, in 1654. In 1660 Stoffels and Titus, now nineteen years old, set up an art store, giving Rembrandt room and board in exchange for his art – an arrangement intended to save Rembrandt from persecution by his creditors.

He continued to receive major commissions, but his style became progressively more introverted as he worked to meet his own standards rather than those of his patrons. Still, *The Syndics of the Amsterdam Cloth Guild* (Rijksmuseum, Amsterdam), a group portrait painted in 1662, pleased his patrons.

Rembrandt recorded the changes in his life through approximately eighty self-portraits

Rembrandt recorded the changes in his life through approximately eighty self-portraits. That seen opposite is one of the last, painted in 1669, the year he died. This was a lonely period: Stoffels had died in 1663 and Titus had died in 1668 at the age of only twenty-six. Rembrandt himself died thirteen months after Titus and was buried in a pauper's grave. To the end, Rembrandt remained the 'lord of light': his handling of paint continued to be masterful, the different textures emphasized, the colours still luminous and glowing. But the contours are looser, the brushstrokes broader, the surface not as smooth as in earlier paintings and the use of thick impasto greater.

Rembrandt
Self-Portrait at the Age of 63, 1669
Oil on canvas,
86 x 70.5 cm
(33⅞ x 27¾ in.)
National Gallery,
London

Self-analytical,
Rembrandt portrays
himself as weary,
his face recording
the depth and tragedy
of his life.

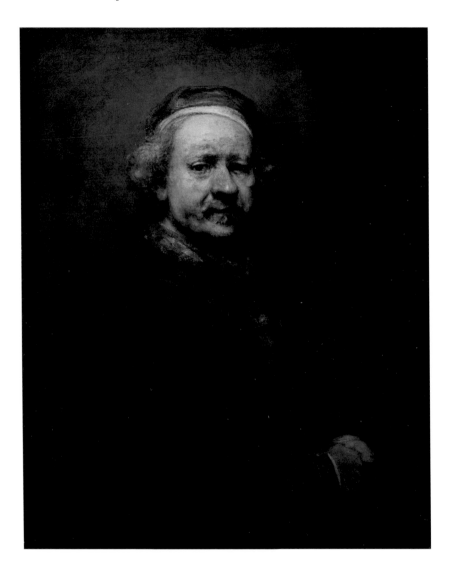

VINCENT VAN GOGH (1853–90)

Vincent van Gogh, the son of a minister, was born in Zundert, the
Netherlands. Before devoting himself to painting, he tried many
different jobs, including art dealer, teacher and lay pastor. But, due
to his difficulties in getting along with people, one failure followed
another. All of Vincent's paintings date between 1880 and 1890,
with the most famous executed in the last few years of his brief life.

Around 1880, following the advice of his younger brother Theo,
who himself was an art dealer, Vincent began a formal art education
in Brussels. His early paintings, such as the *Potato Eaters* (1885;
Van Gogh Museum, Amsterdam), focused on the impoverished
lives of the peasantry and were painted in dark colours.

French Post-Impressionism

In 1886 Vincent moved to Paris, staying with Theo. He embarked
on an academic training and met several of the Impressionists
and Post-Impressionists. Art historians group Vincent with the
French Post-Impressionists because he produced most of his
paintings in France and his interests coincided with theirs. Vincent's
palette changed, becoming vivid and bright. He painted a series of
Sunflowers in 1887 in Paris, and a second series in 1888 while living
in Arles in the south of France. Vincent was able to move there
because of Theo's support, both financial and emotional, which
continued throughout his life.

**The emphasis on outlines and silhouettes reflects
Vincent's admiration for Japanese prints**

Vincent often painted his personal environment, such as
his bedroom in Arles (opposite) – the first of three versions.
The emphasis on outlines and silhouettes reflects his admiration
for Japanese prints, as do the abrupt transitions between bright
colours. Similarly, *Café at Night* (Yale University Art Gallery,
New Haven), also painted in Arles in 1888, has pure colours
applied at maximum intensity rather than mixed and muted on
the palette.

Emotional Anquish

Above all, his paintings reflect his fiery and passionate personality,
his nervous energy appearing in the short choppy brushstrokes.
He put his own emotions into every painting, no matter the subject.

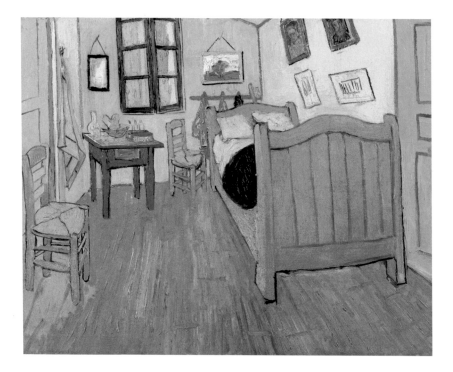

Vincent van Gogh
The Bedroom, 1888
Oil on canvas,
72.4 x 91.3 cm
(28⅝ x 36 in.)
Van Gogh Museum,
Amsterdam

**Vincent repeatedly
documented his
frequently changed
surroundings as well
as his fluctuating
emotions in his paintings
and in his letters to his
brother Theo.**

In this sense, *all* of his paintings are self-portraits – not of his outer physical appearance but of his inner emotional condition.

After a fight with Gauguin, the self-destructive Vincent cut off most of his own left ear

The French Post-Impressionist painter Paul Gauguin accepted Vincent's invitation to visit him in Arles. Vincent admired Gauguin and they influenced each other's art. But they quarrelled terribly. After a fight with Gauguin, the self-destructive Vincent cut off most of his own left ear (according to a drawing made by his doctor Félix Rey), wrapped it and delivered it to a prostitute he patronized. He suffered from intermittent seizures and hallucinations; fully aware of his condition, he voluntarily hospitalized himself in Arles. He continued to record his immediate vicinity in paintings and drawings, such as those that depict the hospital's common room and cloister garden.

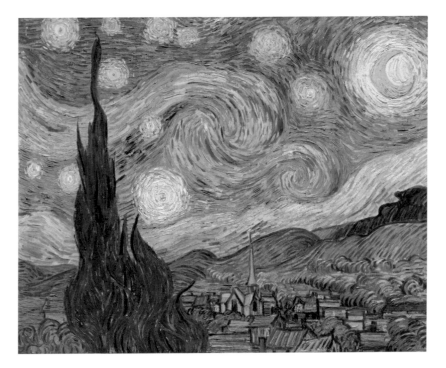

Vincent van Gogh
The Starry Night, 1889
Oil on canvas,
73.7 x 92.1 cm
(29 x 36¼ in.)
Museum of Modern Art,
New York

Landscapes are usually
painted to convey a sense
of peaceful calm. But
Vincent's painting of *The
Starry Night* may be
the most emotional
landscape ever painted,
displaying a turbulence
not exceeded even by
nature's extremes.

Vincent moved to the asylum in Saint-Rémy, a small town not far from Arles, where he lived from May 1889 to May 1890. During this time, he painted with great speed, producing approximately 150 canvases. Among them, and perhaps the best known of all of Vincent's paintings, is *The Starry Night* (1889; opposite).

Nature is turbulent and tormented, bursting with energy, pulsating with vitality as the sky swirls, whirls and twirls

Vincent's letters to Theo make clear that he linked his emotional state to his choice of colours and brushwork. When feeling at peace with himself, Vincent explained, he used placid colour and did not use thick impasto. Clearly, this is not how he was feeling when he painted *The Starry Night*. Everything is in motion in this explosive landscape. He applied paint with a brush, also more rapidly with a palette knife and even squeezed paint directly from the tube – as if to get his ideas on canvas as quickly as possible.

The Starry Night appears to be spontaneous, as if painted in a fevered rush. Nature is turbulent and tormented, bursting with energy, pulsating with vitality as the sky swirls, whirls and twirls. But, in fact, Vincent planned *The Starry Night* in advance. He wrote to Theo explaining that he thinks everything through, 'down to the last detail', and then quickly paints a number of canvases, sometimes working well into the night without stopping to eat.

Chronically restless, Vincent moved to Auvers, near Paris, where the homeopath Dr Paul Gachet, himself an amateur artist, cared for him. He stayed at the Auberge Ravoux, where he was treated like a member of the Ravoux family. In 1890 Vincent painted the *Church at Auvers* (Musée d'Orsay, Paris), applying the thick paint with brushstrokes that follow the Gothic shapes, adding curves to their contours, thereby giving inanimate objects a sense of life.

His final canvas may have been *Wheatfield with Crows* (1890; following pages). On 19 July 1890, while in a wheatfield he had painted several times, he shot himself in the chest or abdomen. Vincent died in Theo's arms a day and a half later, at the age of thirty-seven, never knowing fame during his lifetime. Sadder still, Theo died only six months after Vincent. Now they are buried side by side in Auvers.

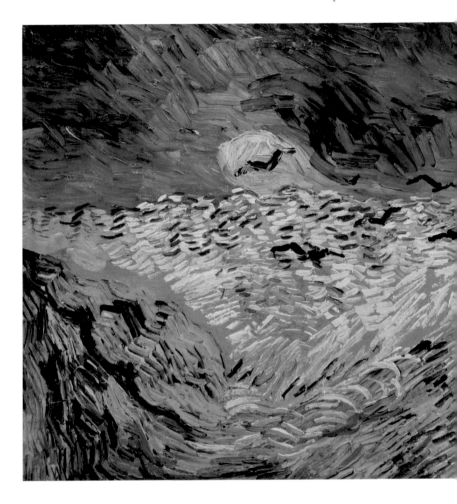

Vincent van Gogh
Wheatfield with Crows,
1890
Oil on canvas,
50.2 x 103 cm
(19¾ x 41 in.)
Van Gogh Museum,
Amsterdam

Van Gogh ended his
own life after having
repeatedly shown himself
to be self-destructive
and having previously
attempted suicide. The
recent suggestions that
Van Gogh was murdered
by a teenage boy or
that he shot himself
accidently have been
largely discredited.

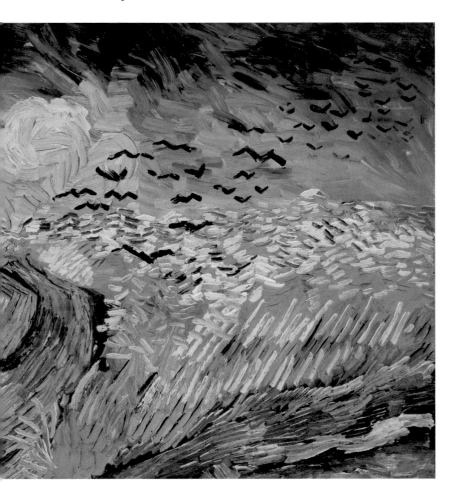

FRIDA KAHLO (1907–54)

The intriguing painter Frida Kahlo was born in Coyoacán, Mexico City, to a Mexican mother and a German-born father. Her paintings are largely autobiographical, frequently referring to the many physical and emotional difficulties of her life. She contracted polio at the age of six, which affected her right leg. A tram accident at the age of eighteen damaged her spine, internal organs and right foot, leaving her partially crippled and in chronic pain. Her appearance was striking, due especially to her unibrow and slight moustache, and she dressed to attract attention. She was witty, social, outgoing and unpretentious. She smoked, drank, cursed, sang bawdy songs and liked dirty jokes. She had talent, ambition, intelligence and a flair for the dramatic. She married the Mexican painter Diego Rivera – twice. Neither was faithful, including her affair with Leon Trotsky and Diego's with Frida's sister Cristina. Doctors amputated her gangrenous right leg at the knee shortly before her death at the age of forty-seven.

Painful Personal Portraiture in Mexico

Kahlo created fifty-five self-portraits, and most of her other paintings refer directly to her experiences. These paintings present an intimate visual autobiography of a riveting personality and an unusually intense life.

-

**The heart of the right figure is intact,
while the heart of the left figure is ripped open**

-

Kahlo's self-portraits simultaneously document her distinctive physical features and the pain she underwent. Among her many self-portraits, *The Two Fridas* (1939; opposite), painted just after her divorce from Diego Rivera, is a symbolic depiction of her suffering. The two Fridas sit side by side, staring at the viewer. The double image represents her lineage: on the left, she wears European Victorian clothing – a high-collared lacy dress. On the right, she wears colourful Mexican peasant attire and holds a tiny portrait of Diego. An artery runs from heart to heart – they share the same blood, and they hold hands. The heart of the right figure is intact, while the heart of the left figure is ripped open.

Due to complications from her injuries in the tram accident, Kahlo passed much of her life confined to bed. She was either in a hospital for surgery, often involving her spine, or immobilized at

Frida Kahlo
The Two Fridas, 1939
Oil on canvas,
171.9 x 171.9 cm
(67¾ x 67¾ in.)
Museo de Arte Moderno,
Instituto Nacional de
Bellas Artes y Literatura,
Mexico City

Perhaps no other artist has ever given viewers such complete access to the many difficulties of her life as Kahlo. Here she shows the European (her father) and Mexican (her mother) halves of her lineage and the complex relationship between them.

home recovering from surgery. She underwent thirty to thirty-five operations or other surgical procedures. There would be twenty-eight plaster corsets, as well as other forms of back braces made of leather and metal, seen in *The Broken Column* (1944; following page), in which her spine is replaced by a crumbling classical Ionic column. Kahlo said, 'I am not sick . . . I am broken . . . but I am happy to be alive as long as I can paint . . .'

When asked why she portrayed herself so frequently, she answered, 'because I am all alone and because I am the subject I know best'. The French writer and founder of Surrealism, André Breton, described Kahlo as a natural Surrealist, but Kahlo said she was painting her own reality rather than her dreams.

Frida's mother disapproved of Frida's marriage to Diego Rivera, the twice-divorced womanizer, who was much older – he was

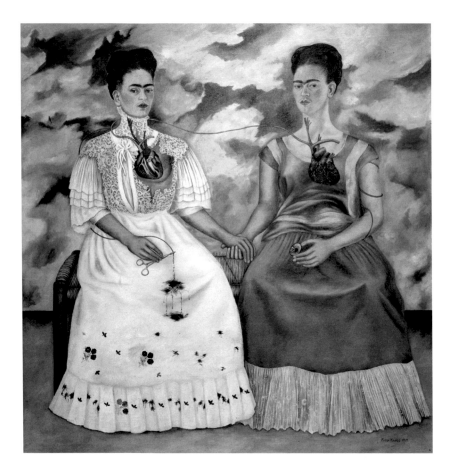

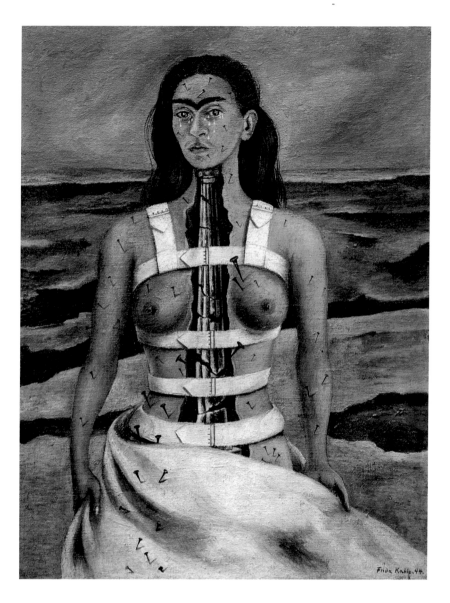

forty-two and Frida twenty-two at the time – and much larger at
1.85 metres (6 foot 1 inch) and approximately 136 kg (300 pounds)
than delicate Frida at 1.6 metres (5 foot 3 inches) and 44.5
kilograms (98 pounds). Her mother described it as a marriage
between an elephant and a dove. Both Kahlo and Rivera had
volatile temperaments and both were repeatedly unfaithful.

Opposite: Frida Kahlo
The Broken Column, 1944
Oil on masonite,
39.8 x 30.6 cm
(15¾ x 12 in.)
Museo Dolores Olmedo,
Mexico City

The physical pain Kahlo
endured during most of
her life resulted from
polio that affected one
leg, the damage her
body suffered in a tram
accident, and the many
subsequent surgeries
and braces that failed to
repair her spine. She said,
'My painting carries with
it the message of pain.'

But he encouraged her painting and praised her art. Mexico revered
Rivera, and his endorsement of her as an artist meant everything
to Kahlo. In her painting *Diego and I* (1949; below), Diego is literally
on her mind and tears fall from her eyes while her hair seems to
strangle her.

In her art, Kahlo followed Rivera's advice and painted in her
own very personal style, rather than following prevailing fashion.
The detailed documentary quality of her paintings adds to their
impact. Perhaps there is some validity to critics' descriptions of
her style as naïve or folk art – but it is very sophisticated naïve
folk art, and this effect is surely intentional. Kahlo's sense of self
overrides all else.

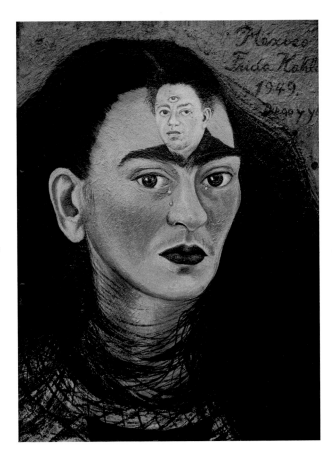

Frida Kahlo
Diego and I, 1949
Oil on canvas and
masonite, 29.5 x 22.4 cm
(11⅝ x 8¾ in.)
Private collection

The major source of
Kahlo's emotional
suffering was her
relationship with the
Mexican painter Diego
Rivera to whom she was
wed twice. Kahlo said,
'There have been two
great accidents in my
life. One was the trolley,
and the other was
Diego. Diego was by
far the worst.'

PABLO PICASSO (1881–1973)

Pablo Picasso is widely considered the most important painter of the twentieth century due to his immense influence on later styles of art. Constantly searching for new means of expression, he created several innovative styles, seemingly changing his style with almost the same frequency that he changed lovers and wives during his ninety-one years of vitality, energy and productivity.

Always Innovating from Spain to France

Born in Málaga in southern Spain, Picasso had a conventional art training at the Royal Academy in Madrid. He moved to Paris in 1900 and there he studied Impressionism and Post-Impressionism. During Picasso's early Blue Period, his paintings were literally blue in colour and figuratively blue in mood, reflecting his destitute life. In paintings such as *The Tragedy* (1903; page 59) and *The Old Guitarist* (1903–4; opposite), the bodies are emaciated and angular, the lines rough and harsh, the effect stark and severe.

As Picasso's life improved, his colours lightened and warmed. He gradually transitioned into his Pink or Rose Period, painting with chalky pink and terracotta colours. Becoming increasingly concerned with aesthetic problems, in 1907 Picasso painted *Les Demoiselles d'Avignon* (*The Young Ladies of Avignon*; Museum of Modern Art, New York), in which the bodies of five women and the background, painted in colours typical of his Pink Period, appear to be fractured into angular shards.

-

**Constantly searching for new means of expression,
Picasso created several innovative styles**

-

Les Demoiselles d'Avignon was a precursor of fully formed Cubism, which appeared in Paris around 1908, developed by Picasso and others, especially Georges Braque. The first stage, called Analytical Cubism, was concerned with investigating principles of composition and simplifying natural objects into geometric shapes, as seen in Picasso's *Girl with a Mandolin* (1910; page 156). Forms are broken down into thin transparent planes defined by lines and angles, tilted, juxtaposed and overlapped. Picasso gives us a series of fragmentary views that analyse various aspects of the form from several points of view, rather than from one fixed vantage point. Nature *is* Picasso's starting point, but he moves so far in the direction of abstraction that it may take you a moment to find

Pablo Picasso
The Old Guitarist, 1903–4
Oil on wood,
122.9 x 82.6 cm
(48⅜ x 32½ in.)
Art Institute of Chicago,
Chicago

Picasso's Blue Period was connected with the suicide of his friend, the poet and painter Carles Casagemas, in 1901. Depressed and impoverished, Picasso shared a room in Paris with the poet Max Jacob where Picasso slept during the day and worked at night, while Jacob slept at night and worked during the day.

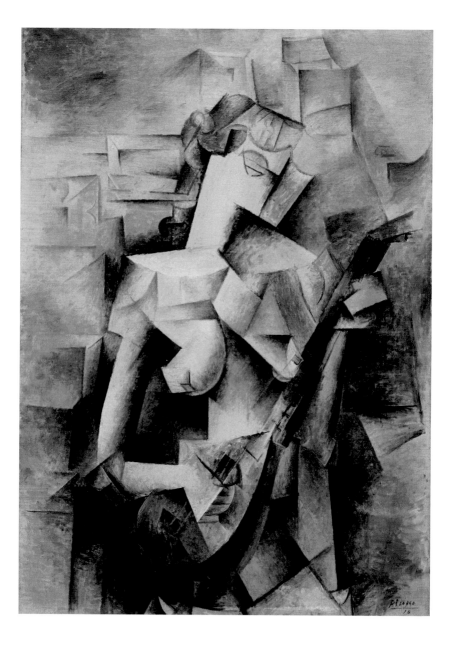

Pablo Picasso
*Girl with a Mandolin
(Fanny Tellier)*, 1910
Oil on canvas,
100.3 x 73.6 cm
(39½ x 29 in.)
Museum of Modern Art,
New York

**Analytical Cubism
was influenced by the
work of the French
Post-Impressionist Paul
Cézanne who said, 'deal
with nature by means of
the cylinder, the sphere,
and the cone, all placed
in perspective.' Cubism
would have great impact
on later styles.**

the figure. Cubist paintings are intentionally almost monochromatic so that colour will not distract from this new way of analysing forms in space.

Picasso's next phase was Collage Cubism, represented by his 1912 *Still Life with Chair Caning* (Musée Picasso, Paris), made of oil paint and oilcloth on canvas framed with a rope. The word *collage* comes from the French for 'paste' or 'glue' because the artist affixes different materials to the support (see pages 88 and 90). Rather than *breaking down* natural forms into little facets and planes, as in Analytical Cubism, now the artist *builds up* the picture. All forms are on the surface, emphasizing the two-dimensionality of the picture plane.

Following Collage Cubism, Picasso, with others, moved on to Synthetic Cubism, Cubism's third phase, represented by Picasso's *Three Musicians* (1921; below). Freely assembled flat geometric forms, more decorative and colourful than before, build up striking designs of rich variety. Clever and inventive with visual puns, this painting depicts three musicians and a dog. While there is little resemblance to reality here, Picasso always retains an identifiable subject. Each object is depicted from a single point of view in Synthetic Cubism, rather than from multiple points of view as in Analytical Cubism.

Pablo Picasso
Three Musicians, 1921
Oil on canvas,
200.7 x 222.9 cm
(79 x 87¾ in.)
Museum of Modern Art,
New York

**Synthetic Cubism was
among the many styles
Picasso created. These
styles might overlap as he
was able to work in more
than one style at a time.
Perhaps this is analogous
to how he repeatedly
changed mistresses and
wives, often involved
with more than one
simultaneously.**

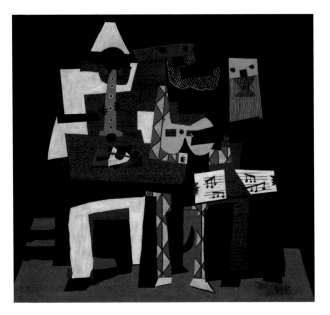

At the same time he was painting in the style of Synthetic Cubism, Picasso also entered his Classical Period and was working in a more naturalistic style that had affinities with classical Greek sculpture. Now the figures had normal proportions and were shaded to appear three-dimensional, for example Picasso's 1921 *Mother and Child* (Art Institute of Chicago, Chicago). Picasso remained interested in painting traditional subjects throughout his life.

Pablo Picasso
Guernica, 1937
Oil on canvas,
3.49 x 7.77 m
(11 ft 5⅜ in. x
25 ft 5½ in.)
Museo Nacional Centro
de Arte Reina Sofía,
Madrid

-

Working on a large scale and using a limited colour palette, Picasso was able to convey extraordinarily powerful emotion

-

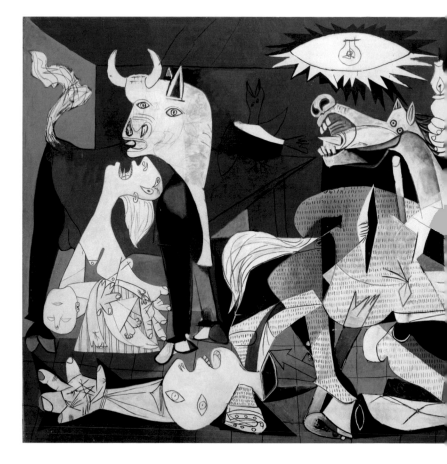

Picasso supported the anti-fascist side of the Spanish Civil War and never returned to Spain after Franco's victory. In accordance with Picasso's will, *Guernica* was moved to Spain only after Franco's death. Picasso painted jagged, disjointed, faceted shapes combined with overt facial expressions and poses to communicate his outrage at this war.

Among the most dramatic and emphatic anti-war images ever created is Picasso's *Guernica* (below), painted in 1937 during the Spanish Civil War (1936–9), shortly after German bombers destroyed Guernica, the capital of the Basque region in northern Spain. Working on the large scale of a mural and using a very limited colour palette of only black, white and grey, Picasso was able to convey extraordinarily powerful emotion. The trampled soldier in the lower left corner, still holding his broken sword, represents the men who fought until death. Above him is a symbolic *pietà* – a mother mourning the dead child in her lap – a reference to Mary and Jesus. The distorted, contorted, broken, twisted anatomy of all the figures enhances the arrestingly passionate quality.

ANDY WARHOL (1928–87)

Just as the term Op Art is a shortening of Optical Art, the
term Pop Art is a shortening of Popular Art. Andy Warhol is the
quintessential Pop artist, famous (or infamous) as the leader of a
new art movement.

He was born Andrew Warhola in Pittsburg, Pennsylvania, into a
working-class family. A good student, he graduated from Carnegie
Institute of Technology (now Carnegie Mellon University) in
1949 with a Bachelor of Fine Arts degree in Pictorial Design. He
changed his name to Warhol and moved to New York City. Soon
his illustrations appeared in *Glamour* magazine for an article aptly
titled 'Success Is a Job in New York'. Warhol was talented, worked
unusually hard and was extremely successful as a commercial artist.
He bought a townhouse in Manhattan where he lived with his
mother and a great many cats (twenty-five at their maximum),
all named Sam, except one.

King of American Pop Art

The image most often associated with Warhol is that of a can –
or cans – of Campbell's soup (opposite). This example is from
1962, the year in which he began to produce the now iconic image.
Pop Art portrays common consumer items such as soup cans,
boxes of Brillo cleaning pads and Coca-Cola bottles, previously
not considered suitable subject matter for artists. Warhol depicts
the familiar impersonally and without comment: Pop Art does not
oppose or criticize. Instead, Pop Art encourages the viewer to look
at ordinary things with fresh eyes.

Some of these images had a very personal connection for
Warhol. He said about Campbell's soup, 'I used to drink it. I used to
have the same lunch every day, for twenty years. I guess, the same
thing, over and over again.' Correspondingly, in his art he created
the same image 'over and over again'. And there was actually a
deeper meaning to other commercial products for Warhol. He
regarded Coca-Cola as a social leveller, because it is something
shared by people from all backgrounds, no matter their status or
wealth, he said, from 'the President' to 'Liz Taylor' to 'the bum on
the corner'.

Celebrities fascinated Warhol from childhood. He actively
sought personal celebrity, not just financial success. Perhaps his
most frequently repeated quote is, 'In the future, everybody will
be world famous for 15 minutes.' In 1962, in addition to the
soup can series, he started a series of portraits of movie stars.
The *Marilyn Diptych* (page 162), produced shortly after her death,

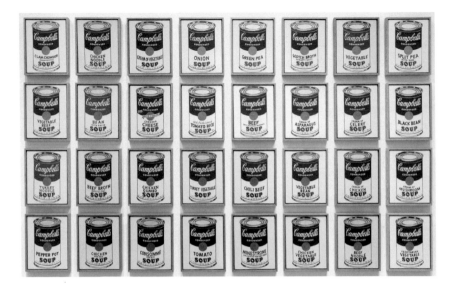

Andy Warhol
Campbell's Soup Cans,
1962
Acrylic with metallic
enamel paint on canvas,
overall installation
2.46 x 4.14 m
(8 ft 1 in. x 13 ft 7 in.)
Museum of Modern Art,
New York

**Warhol elevates an
ordinary commercial
item to the level of art,
thereby inviting us to see
the art in the ordinary.
He said, 'I don't think art
should be only for the
select few,' explaining,
'I think it should be
for the mass of the
American people.'**

is one of many works he made based on photographs of the actress.
When Elizabeth Taylor was sick in 1963 Warhol made her his focus.
Similarly, Warhol portrayed Elvis Presley in multiple images, starting
in 1963. Especially attracted to images of tragedy, Jackie Kennedy
was the subject of multiple prints after the assassination of her
husband, President John F. Kennedy, in 1963.

Warhol worked from photographs and used silkscreen printing to produce multiple, nearly identical images

Warhol's early Pop Art images were hand-painted, but soon
less and less of his work showed the physical hand of the artist.
Instead, he worked from photographs and used silkscreen printing
to produce multiple, nearly identical images. Warhol further broke
down the traditional long-standing barrier between fine art and
commercial art by producing portraits of famous people using
commercial rather than traditional fine art techniques.

Physically, Warhol was tall and very thin, with a pale complexion
he made even whiter by applying make-up and, at times, dyeing
his eyebrows white. His natural hair colour was brown, but he
became bald while still quite young and wore wigs – which he
refused to acknowledge. He even had his wigs cut by a hairstylist;
a month later, he would put on another longer wig and go back to

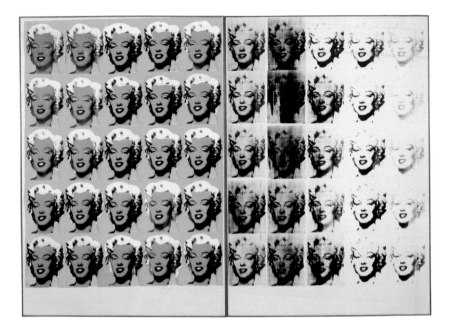

the hairstylist for a trim. People who knew Warhol described him as a workaholic with extraordinary energy. His studio was dubbed The Factory because of the quantity of work produced there. The Factory was also the site of wild parties and illicit drug use, and the meeting place for the intelligentsia, the rich and the Hollywood famous as well as drag queens and street people.

Everything changed on 3 June 1968 when Valerie Solanas, radical feminist and struggling writer of off-colour plays, entered The Factory and shot Warhol. The bullet passed through both lungs, his spleen, stomach, liver and oesophagus. Barely surviving, his health was permanently impaired.

Warhol received a commission in 1984 to create something based on Leonardo da Vinci's famous *Last Supper* (pages 134–5) for exhibition in an art gallery across the street from the convent where Leonardo's mural is located. Warhol was, in fact, deeply religious and attended church regularly. He combined Leonardo's masterpiece with images from popular commercial advertising, amalgamating the sacred and the secular (pages 164–5). Irreverent? Perhaps. Relevant to contemporary life? Definitely. The exhibition of Warhol's *Last Supper* series opened in January 1987. It turned out to be his last major project.

In February 1987 he underwent the gallbladder surgery he had delayed due to his fear of doctors and hospitals. Although the

Andy Warhol
Marilyn Diptych, 1962
Silkscreen ink and acrylic
paint on two canvases,
205.4 x 289.6 cm
(80⅞ x 114 in.)
Tate Collection, UK

**Warhol's diverse interests
included a fascination
with celebrities – and
a desire to become one
himself. He was active in
many different projects
including music, film,
television, and even
magazine and book
publication.**

surgery went smoothly, he died the next day, age fifty-eight, in Manhattan's New York Hospital, due to cardiac arrhythmia. His private nurse had fallen asleep while he was receiving intravenous fluids, allowing him to become over-hydrated, and he was unable to breathe normally as a result of the gunshot wound.

Warhol's work elicits a range of reactions, positive and negative. Even though some critics remain hostile to his work, there is general agreement that he captured the spirit of the American culture of his day.

KEY ARTISTS AND IDEAS

Leonardo da Vinci (1452–1519):

Science and art unite in Renaissance Italy

First-hand study of natural world

Technical innovations

Chiaroscuro and *sfumato*

Rembrandt (1606–69):

Golden Age of painting in Holland

Popularity of portraiture

Self-portraits

Rembrandt's personal and professional rise and fall

Vincent van Gogh (1853–90):

Post-Impressionism in France

Art and emotional anguish

Impasto and vivid unnatural colour

Relationship with his brother Theo

Frida Kahlo (1907–54):

Painting as a visual diary in Mexico

Polio, tram accident and surgeries

Marriages to Diego Rivera

Pablo Picasso (1881–1973):

From Spain to France

Blue Period and Pink or Rose Period

Cubism: Analytical, Collage and Synthetic

Classical Period

Andy Warhol (1928–87):

Pop (Popular) Art in America

Finding interest in the ordinary

Fine art and commercial art

The Factory as a creative hub

Andy Warhol
The Last Supper, 1986
Screenprint and coloured
graphic art paper collage
on handmade paper,
59.7 x 80.6 cm
(23½ x 31¾ in.)
The Andy Warhol
Museum, Pittsburgh

**Warhol kept his public
and private lives quite
separate. His public
persona involved an
extreme lifestyle, yet he
was also religious, gave
money to people in need,
lived with his mother
for years and kept many
(many) cats as well as
dogs as pets.**

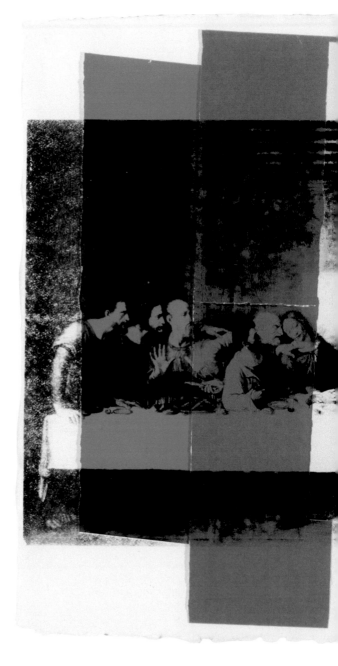

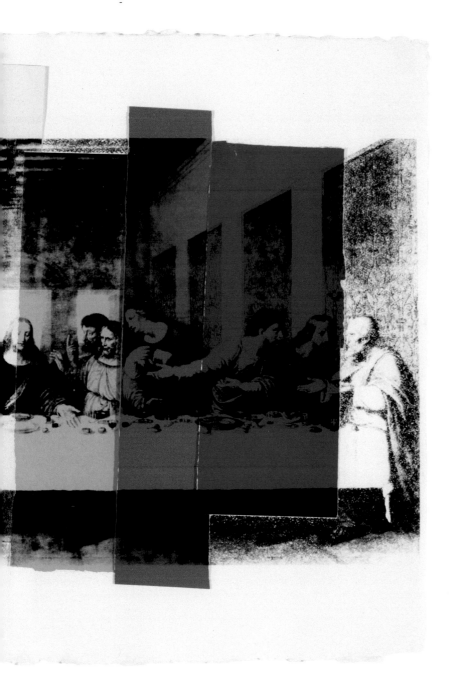

GLOSSARY

Acrylic paint: see **Synthetic paint**.

Advancing and receding colours: see **Warm and cool colours**.

Asymmetry: see **Symmetry**.

Atmospheric (aerial) perspective: a painting technique that achieves an illusion of depth by copying the atmospheric phenomenon that causes objects at a distance to appear less distinct and their colours less intense than those nearby.

Bilateral symmetry: see **Symmetry**.

Broken colour: a painting technique introduced by the Impressionists in which each colour is broken down or divided into its component colours. Thus if an area is to appear orange, dabs of yellow and red are applied to the painting and are subsequently 'mixed' by the viewer's eyes.

Burin: a cutting tool usually consisting of a wood handle and metal shaft ending in a sharply pointed tip, used to create an engraving.

Canvas: heavy linen fabric made from the fibrous flax plant, first used to paint on with oils in early sixteenth-century Italy. Flax is also the source of linseed oil used in oil paint.

Casein: paint binder made by drying curds from sour skim milk; used to paint on dry plaster.

Champlevé: see **Enamel**.

Chiaroscuro: term derived from the combined Italian words for 'light' and 'dark', or 'clear' and 'obscure', which refers to a painting style using areas of light and shadow.

Cloisonné: see **Enamel**.

Complementary colours: pairs of colours across from one another on a standard colour wheel, in which each pair consists of one primary and one secondary colour. Hence, yellow and purple, red and green, blue and orange.

Continuous narration: a visual device used to tell a story that includes several separate events. The viewer knows these events occurred sequentially, yet the artist portrays them simultaneously, without separating them into different frames.

Contrapposto: Italian for 'counterpoise', the term for a pose introduced in fifth-century BCE Greece in which the figure stands with the weight on one leg, raising one hip and the opposite shoulder and putting the spine into a slight S-curve.

Distemper: a painting technique that uses a mixture of earth-coloured pigments, a binder of plant or animal origin and water applied to dry plaster.

Divisionism: a painting technique developed by the French Post-Impressionist Georges Seurat, who separated each colour into its component hues. The technique is also known as **pointillism** because he applied those colours in small points or dots.

Drypoint: see **Intaglio techniques**.

Egg tempera: a painting technique that uses an emulsion of egg yolk and water as the binder. This technique reached its peak during the Middle Ages in Europe.

Enamel: an artistic technique in which coloured glass powder or paste is applied to metal. The two main types of enamel are **cloisonné** on gold using tiny raised borders or cells to divide the colours, and **champlevé** on a gilded base metal with recesses carved to hold the colours. In both types of enamel, firing the object in a kiln or furnace at a high temperature causes the powder or paste to vitrify, producing vivid jewel-like colours.

Encaustic: a painting technique that uses hot wax as the binder.

Engraving: see **Intaglio techniques**.

Etching: see **Intaglio techniques**.

Fresco: mural painting technique. The two basic types are *buon fresco* (also called *fresco buono*) painted on wet plaster, and *fresco secco* painted on dry plaster.

Gesso: thick white paint applied to a canvas, wood panel, or sculpture to prepare the surface to receive paint.

Glaze: a thin transparent glass-like coating.

Gouache: see **Watercolour and gouache**.

Gouge: a cutting tool usually consisting of a wood handle and metal shaft ending in a U- or V-shaped point, used to remove small pieces of wood or metal to create a design for printing.

Hatching: a drawing technique in which a series of closely spaced parallel lines model a shape. In **cross-hatching** the lines cross to form a grid to produce the same effect.

Hue: refers to the actual colour, such as red or orange or purple.

Iconography: the language of symbols, used to convey information without written words, often found in religious art.

Impasto: thick paint applied to a surface.

Intaglio techniques: used to create prints on paper. In all intaglio techniques, indentations created in a metal plate receive the ink. To make an **engraving**, cut grooves into the plate with a gouge or burin. To make a **drypoint**, push a pointed tool along the plate without removing any metal, instead kicking up a burr of metal particles on either side of each line. To make an **etching**, cover the surface of the plate with a waxy acid-resistant ground and scratch lines through the ground with a sharp point; when placed in a mild acid bath, the acid etches the scratched lines where the plate is exposed. Additional intaglio techniques are **aquatint** and **mezzotint**, each used to create shades of grey.

Intensity or **saturation**: describes how vivid a colour is, the highest level being pure colour. To lower the intensity, add the complement of the colour.

Kinetic sculpture: sculpture that involves movement as an essential feature of its effect, such as Alexander Calder's mobiles.

Linear perspective: a device to create an illusion of three-dimensional space on

a two-dimensional **picture plane**. Lines intended to appear to recede into space converge towards one or more vanishing points on the horizon line.

Lithograph: a technique to print on paper by drawing the image on a smooth limestone block with a greasy substance such as an oil crayon. Treatment of the stone surface with a mixture of mild acid and gum arabic causes a chemical change in the areas not protected by the grease. Oil-based ink rolled onto the stone adheres only to the greasy areas.

Lost-wax technique: a method of metal casting for hollow objects, often referred to by the French term *cire perdue*. A layer of wax coats the object and a mould encases the whole. When heated, the wax melts and is 'lost', and that space is then filled with molten metal.

Manuscript illumination: manuscripts are hand-written books; the illustrations they contain are referred to as illuminations.

Masterpiece: a work of art displaying extremely high skill. The term derives from the medieval and Renaissance education for artists in which the student had to demonstrate mastery of skills by creating a masterpiece and therefore qualified to become a master and take students.

Mixed technique: a fifteenth-century painting technique transitional between **egg tempera** and **oil paint**, in which a layer of egg tempera precedes a layer of oil paint, utilizing the advantages of each. Because one is water-based and the other oil-based, the layers will not dissolve each other.

Mosaic: a technique akin to **fresco** but instead of painting on wet plaster, small cubes of coloured material called **tesserae** (from the Greek word for 'four' because of the four corners visible on each cube) are pressed into the wet plaster. Tesserae may also be irregular in shape.

Narrative conventions: devices employed by artists to convey meaning visually, including various nonverbal images that have commonly accepted meanings.

Oil paint: a painting technique using a vegetable drying oil (usually linseed oil) as the binder. Mixing a lot of oil with a little pigment produces a thin **glaze**; mixing a little oil with a lot of pigment produces thick **impasto**.

Orthogonal lines: the diagonal lines in a drawing made using linear perspective that appear to recede into depth toward an imagined vanishing point or points.

Paint: all types of paint consist of pigment in the form of ground particles of coloured material and a binder, which is the glue that holds the particles of pigment together and causes them to adhere to a surface.

Parchment: carefully prepared animal skin on which manuscripts are written and illuminated. Parchment is made from cow skin, while **vellum**, which is thinner and finer, is from calfskin.

Picture plane: a flat surface such as paper, canvas, or a wall on which an image is painted or drawn.

Pointillism: see **Divisionism**.

Predella: small panels attached below the main panel of an altarpiece, usually painted with scenes related to the subject depicted on the main panel.

Primary colours: the subtractive (or pigment) colour primaries are yellow, blue and red, with which it is possible to create all other colours except black or white. The additive (or light) colour primaries are green, blue and red, and are used with film and digital formats.

Proportion: the relationship between the sizes of elements in a work of art. Certain proportions seem to be more satisfying to the eye than others. Artists and architects have long used mathematical ratios to create aesthetically pleasing proportions for, among other things, the human body and buildings.

Relief sculpture: sculpture in which three-dimensional forms project from a background of which they are a part. Relief sculpture is described according to the degree of projection, ranging from very high (*alto-relief*) to very low (*bas-relief*).

Relieved bilateral symmetry: see **Symmetry**.

Saturation: see **Intensity**.

Secondary colours: of paint pigment are green, purple and orange, each made by mixing two **primary colours**.

Serigraphy (silkscreen, screenprint): a technique to print on paper in which finely woven silk is stretched over a wood frame, and a stencil blocks the areas that are not to print. Thick ink –pulled across the screen with a squeegee – penetrates the weave of the silk and prints on the paper below. Today synthetic fabrics may replace the silk.

Sfumato: a term derived from the Italian for 'smoke', a painting style in which the outlines soften and blend with the background creating a slightly hazy effect suggesting the surrounding atmosphere.

Stained glass: a technique used especially for medieval church windows. Molten glass is naturally greenish but becomes yellowish or reddish if boiled longer. The addition of powdered metallic oxides creates a range of colours.

Symmetry: if a line down the centre of a composition divides it into two identical mirror images, it exhibits perfect **bilateral symmetry**. If the two sides of a composition are similar, but not absolutely identical, this is **relieved bilateral symmetry**. If the two sides of a composition are entirely different, this is **asymmetry**, which means 'without symmetry'.

Synthetic paint (acrylic paint, plastic paint): a painting technique using pigment dispersed in an acrylic polymer emulsion. Very versatile, synthetic paints can create a wide variety of effects. While wet, synthetic paints dissolve in water.

Tenebrism: a term derived from *tenebroso*, Italian for 'dark', which refers to a painting style in which strong light intensifies the centre of interest, highlights expressive features and subordinates unimportant details in the shadows. ***Chiaroscuro***, if taken to an extreme with exaggerated contrasts of light and dark, becomes **tenebrism**.

Terracotta: Italian for 'baked earth', a natural clay used for sculpture and pottery, usually orange-brown in colour.

Tesserae: see **Mosaic**.

Unity: a desirable quality in a work of art in which all parts appear connected and cohesive. Repetition of similar shapes, brushstrokes, textures, colours or other qualities can create unity.

Value of a colour: refers to how light or dark a colour is. To raise the value, add white, thereby creating a tint or pastel; to lower the value, add black, thereby creating a shade.

Vellum: see **Parchment**.

Visual force: a device employed to achieve balance in a composition based on the fact that certain things attract visual attention sooner and hold it longer than others. Forms that are large, bright in colour, visibly textured and imply movement exert greater visual force than forms that are small, dull, indistinctly textured and static. The centre of a composition also exerts force, drawing our eyes to it, presumably because we are accustomed to finding the 'centre of attention' at the physical centre of a composition.

Warm and cool colours (advancing and receding colours): warm colours such as red and orange appear to advance forwards in a painting, whereas cool colours such as green and blue appear to recede into depth.

Watercolour and gouache: painting media that consist of pigment combined with water, a binder such as gum arabic, and ingredients like glycerin or honey, or both, to improve the consistency and colour, as well as preservatives. **Watercolour** is thin and translucent while in **gouache** the larger size of paint particles and higher percentage of pigment make it thicker and more opaque.

Woodblock printing: a technique used to create prints on paper. The printer cuts the design into a block of wood, using a gouge, a wood chisel or a knife to remove the areas not intended to print. Ink is rolled onto the image that remains in relief. For a **woodcut** the block is cut with the grain of the tree, whereas for a **wood engraving** the block is cut across the grain, offering the advantage that the wood-cutting tool encounters equal resistance in all directions.

FURTHER READING

Adamson, Glenn and Julia Bryan-Wilson, *Art in the Making: Artists and their Materials from the Studio to Crowdsourcing* (Thames & Hudson, London and New York, 2016)

Benton, Janetta Rebold and Robert DiYanni, *Arts and Culture: An Introduction to the Humanities* (Pearson, Upper Saddle River, NJ, 4th edn, 2012)

Benton, Janetta Rebold and Robert DiYanni, *Handbook for the Humanities* (Pearson, Upper Saddle River, NJ, 2014)

Brown, Matt, *Everything You Know About Art Is Wrong* (Batsford, London, 2017)

Dickerson, Madelynn, *The Handy Art History Answer Book* (Visible Ink Press, Detroit, MI, 2013)

Goldwater, Robert and Marco Treves (eds), *Artists on Art from the XIV to the XX Century* (Pantheon Books, New York, 3rd edn, 1974)

Hodge, Susie, *The Short Story of Art* (Laurence King Publishing, London, 2017)

Hollein, Max (foreword), *Art = Discovering Infinite Connections in Art History* (Metropolitan Museum of Art, New York, and Phaidon Press, London, 2020)

Kilinski, Karl, *Greek Myth and Western Art: The Presence of the Past* (Cambridge University Press, Cambridge, 2012)

King, Ross (foreword), *Artists: Their Lives and Works* (Dorling Kindersley, London and New York, 2017)

Livingstone, Margaret, *Vision and Art: The Biology of Seeing* (Harry N. Abrams, New York, 2014)

Mayer, Ralph, *The Artist's Handbook of Materials and Techniques* (first pub. 1940; Viking Press, New York, 5th edn, 1991)

Noey, Christopher and Thomas P. Campbell, *The Artist Project: What Artists See When They Look at Art* (Metropolitan Museum of Art, New York, and Phaidon Press, London, 2017)

Obrist, Hans Ulrich, *Lives of the Artists, Lives of the Architects* (Penguin, London, 2016)

Rideal, Liz, *How to Read Art: A Crash Course in Understanding and Interpreting Painting* (Bloomsbury, London, 2014 and Universel, New York, 2015)

Roberts, Helene E. (ed.), *Encyclopedia of Comparative Iconography: Themes Depicted in Works of Art* (Routledge, Abingdon, 1998)

Schlam, Carolyn Dobkin, *The Joy of Art: How to Look At, Appreciate, and Talk about Art* (Allworth Press, New York, 2020)

Vasari, Giorgio, *The Lives of the Artists* (Oxford World's Classics, Oxford University Press, Oxford, reissue edn, 2008)

Wilson, Matt, *Symbols in Art* (Thames & Hudson, London and New York, 2020)

Woodford, Susan, *Looking at Pictures* (Thames & Hudson, London and New York, 2018)

INDEX

Illustrations are in *italics*.

PICTURE ACKNOWLEDGEMENTS

l left **r** right

2, 120 The Metropolitan Museum of Art, New York. Gift of Louis C. Raegner, 1927; **4** National Archives at College Park, Maryland. Still Picture Records Section, Special Media Archives Services Division. 306-NT-694A-1; **8, 14** Private collection. Photo courtesy the artist; **10** Norman Rockwell Museum Collection, Stockbridge. Artwork approved by the Norman Rockwell Family Agency; **11** Kunsthistorisches Museum, Vienna. Photo Superstock/A. Burkatovski/Fine Art Images; **13** Musée national Picasso, Paris. Photo © RMN-Grand Palais (Musée national Picasso-Paris)/Mathieu Rabeau. © Succession Picasso/DACS, London 2021; **16** Musée du Louvre, Paris. Photo © Musée du Louvre, Dist. RMN-Grand Palais/Christian Decamps; **17** Staatsgalerie, Stuttgart. Courtesy of Pest Control Office, Banksy, Love is in the Bin, 2018; **19** The National Gallery, London; **20** Rubin Museum of Art C2002.3.2 (HAR 65046); **21** Museo dell'Opera Metropolitana del Duomo, Siena; **22** Kunsthistorisches Museum, Vienna; **25** The Metropolitan Museum of Art, New York. Harris Brisbane Dick Fund, 1917; **26** Photo © Araldo de Luca. www.araldodeluca.com; **27** British Museum, London. Photo The Trustees of the British Museum. All rights reserved; **29l** Collection Fondation Alberto & Annette Giacometti, Paris. Photo Bridgeman Images. © The Estate of Alberto Giacometti (Fondation Giacometti, Paris and ADAGP, Paris), licensed in the UK by ACS and DACS, London 2021; **29r** Private collection. Photo © Christie's Images/Bridgeman Images. © Fernando Botero; **30** National Gallery of Art, Washington, DC. Gift of Mrs Charles S. Carstairs; **31** Unterlinden Museum, Colmar; **32** Tate, St Ives. Photo Tate; **33** Musée d'Orsay, Paris. Photo © RMN-Grand Palais (Musée d'Orsay)/René-Gabriel Ojéda; **35** Albright-Knox Art Gallery, Buffalo, New York. Gift of Seymour H. Knox, J., 1956. Photo Albright Knox Art Gallery/Art Resource, NY/Scala, Florence; **36, 45** Art Institute of Chicago. Helen Birch Bartlett Memorial Collection; **39** National Gallery of Art, Washington, DC. Gift of Sam A. Lewisohn; **41** Division of Work and Industry, National Museum of American History, Smithsonian Institution; **42** Cleveland Museum of Art. Leonard C. Hanna, Jr Fund; **43** Art Institute of Chicago. Major Acquisitions Fund; **44** Scottish National Gallery, Edinburgh. Purchased with the aid of the Art Fund and a Treasury Grant 1955; **46, 100l** Museo Pio-Clementino, Vatican City. Photo © Scala, Florence; **47** The Museum of Modern Art, New York. Given anonymously. Photo The Museum of Modern Art, New York/Scala, Florence. © Succession Brancusi – All rights reserved. ADAGP, Paris and DACS, London 2021; **48** National Gallery of Art, Washington, DC. Widdener Collection; **49** The Metropolitan Museum of Art, New York. Theodore M. Davis Collection, Bequest of Theodore M. Davis, 1915; **50** The Dan Flavin Art Institute, Bridgehampton. Courtesy Dia Art Foundation, New York. Photo Bill Jacobson Studio, New York. © Stephen Flavin/Artists Rights Society (ARS), New York 2021; **51** Stanza della Segnatura, Apostolic Palace, Vatican City; **52** The Metropolitan Museum of Art, New York. Gift of Mrs Russell Sage, 1908; **53l, 100r** Galleria dell'Accademia, Florence. Photo © Scala, Florence/courtesy Ministero per i Beni e le Attività Culturali e per il Turismo; **53r** Galleria Borghese, Rome. Courtesy Ministero per i Beni e le Attività Culturali e per il Turismo – Galleria Borghese; **55** Arena Chapel, Padua. Photo Granger Historical Picture Archive/Alamy Stock Photo; **56–7** National Gallery of Art, Washington, DC. Chester Dale Collection. © Salvador Dalí, Fundació Gala-Salvador Dalí, DACS 2021; **59** National Gallery of Art, Washington, DC. Chester Dale Collection. © Succession Picasso/DACS, London 2021; **60** Musée Rodin, Paris. Photo Denis Chevalier/akg-images; **61** Philadelphia Museum of Art. The Louise and Walter Arensberg Collection, 1950. © Succession Brancusi – All rights reserved. ADAGP, Paris and DACS, London 2021; **63** Musée Camille Claudel, Nogent-sur-Seine. Photo © Marco Illuminati; **66, 78** Private collection. Photograph by Rob McKeever, courtesy Gagosian. Artwork © 2021 Helen Frankenthaler Foundation, Inc./DACS, London; **68** The Metropolitan

Museum of Art, New York. Rogers Fund, 1909; **70–71** Sistine Chapel, Vatican City; **72** Church of San Vitale, Ravenna; **74** Trinity College Library, Dublin. Courtesy The Board of Trinity College Dublin; **75** National Gallery of Art, Washington, DC. Andrew W. Mellon Collection; **77** Isabella Stewart Gardner Museum, Boston. Photo Bridgeman Images; **79** National Gallery of Art, Washington, DC. Bequest of Julia B. Engel; **80** The Metropolitan Museum of Art, New York. Henry L. Phillips Collection, Bequest of Henry L. Phillips, 1939; **81** The Metropolitan Museum of Art, New York. Harris Brisbane Dick Fund, 1932; **82** The Metropolitan Museum of Art, New York. Bequest of Clifford A. Furst, 1958; **84** The Andy Warhol Museum, Pittsburgh; Founding Collection, Contribution The Andy Warhol Foundation for the Visual Arts, Inc. © 2021 The Andy Warhol Foundation for the Visual Arts, Inc./Licensed by DACS, London; **85** Klosterneuburg Monastery. Photo Peter Boettcher, IMAREAL Krems; **87** Notre-Dame Cathedral, Chartres. Photo World History Archive/Alamy Stock Photo; **89** Courtesy the artist and Metro Pictures, New York; **91** The Metropolitan Museum of Art, New York. Purchase, Foundation of Fine Art of the Century Gift, 1985; **92** The Metropolitan Museum of Art, New York. The Michael C. Rockefeller Memorial Collection, Bequest of Nelson A. Rockefeller, 1979; **93** The Metropolitan Museum of Art, New York. Gift of Mr and Mrs J. J. Klejman, 1964; **94** Collection of D'Achille-Rosone, Little Silver, NJ. Photo courtesy the artist; **95** The Metropolitan Museum of Art, New York. The Michael C. Rockefeller Memorial Collection, Bequest of Nelson A. Rockefeller, 1979; **96** Private collection. On long term loan to the Tate. Photo Tate. © 2021 Calder Foundation, New York/DACS, London; **98, 128–9** Collection of the artist. Courtesy Froelick Gallery, Portland. Photo Ed Eckstein, Easton; **102–3** Sistine Chapel, Vatican City; **105** Obey Giant Art. Courtesy of Shepard Fairey/Obeygiant.com; **106** National Palace Museum, Taipei. Photo De Agostini/Getty Images; **108** St Peter's Church, Leuven; **109** Basilica of San Giorgio Maggiore, Venice; **110** Trajan's Forum, Rome. Photo Araldo de Luca/Corbis via Getty Images; **111** Photo © Dommuseum Hildesheim. Photo Florian Monheim; **112** Museo Nazionale Romano, Terme di Diocleziano, Rome. Su concessione del Ministero per i beni e le attività culturali e per il turismo – Museo Nazionale Romano; **113** Sainte-Marie-Madeleine, Vézelay. Photo akg-images/Stefan Drechsel; **114** The Metropolitan Museum of Art, New York. Bequest of Mrs James W. Gerard, 1956; **116** Museo Nacional del Prado, Madrid. Photo Museo Nacional del Prado, Madrid/Scala, Florence; **117** Private collection; **118** The Metropolitan Museum of Art, New York. Catharine Lorillard Wolfe Collection, Wolfe Fund, 1931; **119** Royal Museums of Fine Arts of Belgium, Brussels; **121** © Succession Picasso/DACS, London 2021; **123** Hilma af Klint Foundation, Stockholm; **125** The Museum of Modern Art, New York. 1935 Acquisition confirmed in 1999 by agreement with the Estate of Kazimir Malevich and made possible with funds from the Mrs John Hay Whitney Bequest (by exchange). Photo The Museum of Modern Art, New York/Scala, Florence; **126** Natural History Museum, Vienna; **130, 152** Museo Dolores Olmedo, Mexico City. Photo Leonard de Selva/Bridgeman Images. © Banco de México Diego Rivera Frida Kahlo Museums Trust, Mexico, D.F./DACS 2021; **133** Musée du Louvre, Paris. Photo Musée du Louvre, Dist. RMN-Grand Palais/Angèle Dequier; **134–5** Santa Maria delle Grazie, Milan; **137** Musée du Louvre, Paris; **138** Städel Museum, Frankfurt am Main. Acquired in 1905 with funds provided by Städelsche Stiftung, Städelscher Museums-Verein, the city of Frankfurt am Main and numerous friends of the museum; **140–41** Rijksmuseum, Amsterdam. On loan from the City of Amsterdam; **143** National Gallery, London; **145** Van Gogh Museum, Amsterdam (Vincent van Gogh Foundation); **146** The Museum of Modern Art, New York. Acquired through the Lillie Bliss Bequest (by exchange). Conservation was made possible by the Bank of America Art Conservation Project. Photo The Museum of Modern Art, New York/Scala, Florence; **148–9** Van Gogh Museum, Amsterdam (Vincent van Gogh Foundation); **151** Collection Museo de Arte Moderno, Consejo Nacional para la Cultura y las Artes – Instituto Nacional de Bellas Artes, Mexico City. © Banco de México Diego Rivera Frida Kahlo Museums Trust, Mexico, D.F./DACS 2021; **153** Private collection. Photo akg-images. © Banco de México Diego Rivera Frida Kahlo Museums Trust, Mexico, D.F./DACS 2021; **155** Art Institute of Chicago. Helen Birch Bartlett Memorial Collection. Photo The Art Institute of Chicago/Art Resource, NY/ Scala, Florence. © Succession Picasso/DACS, London 2021; **156** The Museum of Modern Art, New York. Nelson A. Rockefeller Bequest. Photo The Museum of Modern Art, New York/Scala, Florence. © Succession Picasso/DACS, London 2021; **157** The Museum of Modern Art, New York. Mrs Simon Guggenheim Fund. Photo The Museum of Modern Art, New York/Scala, Florence. © Succession Picasso/DACS, London 2021; **158–9** Museo Nacional Centro de Arte Reina Sofía, Madrid. Photographic Archives Museo Nacional Centro de Arte Reina Sofía. © Succession Picasso/DACS, London 2021; **161** The Museum of Modern Art, New York. Partial gift of Irving Blum. Additional funding provided by Nelson A. Rockefeller Bequest, gift of Mr and Mrs William A. M. Burden, Abby Aldrich Rockefeller Fund, gift of Nina and Gordon Bunshaft, acquired through the Lillie Bliss Bequest, Philip Johnson Fund, Frances R. Keech Bequest, gift of Mrs Bliss Parkinson, and Florence B. Wesley Bequest (all by exchange). Photo The Museum of Modern Art, New York/Scala, Florence. © 2021 The Andy Warhol Foundation for the Visual Arts, Inc./Licensed by DACS, London; **162** Tate. Photo Tate. © 2021 The Andy Warhol Foundation for the Visual Arts, Inc./Licensed by DACS, London; **164–5** The Andy Warhol Museum, Pittsburgh; Founding Collection, Contribution The Andy Warhol Foundation for the Visual Arts, Inc. © 2021 The Andy Warhol Foundation for the Visual Arts, Inc./Licensed by DACS, London

-

For Clare Marie Wedding (1987–2012)
who loved art and would have been a great art historian
With sincere thanks to Elliot Benton, Dr Nona C. Flores,
Dr Stephen Lamia and Prof. Vera Manzi-Schacht

-

First published in the United Kingdom in 2021 by Thames & Hudson Ltd, 181A High Holborn, London WC1V 7QX

First published in the United States of America in 2021 by Thames & Hudson Inc., 500 Fifth Avenue, New York, New York 10110

How to Understand Art © 2021 Thames & Hudson Ltd, London
Text © Janetta Rebold Benton

Design by April
Edited by Caroline Brooke Johnson
Picture research by Nikos Kotsopoulos

British Library Cataloguing-in-Publication Data
A catalogue record for this book is available from the British Library.

Library of Congress Control Number 2021934174
ISBN 978-0-500-29583-0
Printed and bound in China by Toppan Leefung Printing Ltd

Be the first to know about our new releases, exclusive content and author events by visiting
thamesandhudson.com
thamesandhudsonusa.com
thamesandhudson.com.au

Front cover: Flemish School, detail of *Cognoscenti in a Room Hung with Pictures*, c.1620. Oil on oak, 96 x 123.5 cm (37¾ x 48⅝ in.). National Gallery, London. Bequeathed by John Staniforth Beckett, 1889. Photo: The Picture Art Collection/Alamy Stock Photo

Title page: Jean-Léon Gérôme, *Pygmalion and Galatea*, c.1890 (detail of page 120)

Page 4: A visitor to the National Gallery of Art, Washington, DC, scrutinizing Benvenuto Cellini's salt and pepper holder (1540–43) on temporary exhibit, c.1947. Photograph. National Archives, College Park, MD

Chapter openers: page 8 Delphine Diallo, *Hybrid 8*, 2011 (detail of page 14); **page 36** Georges Seurat, *A Sunday on La Grande Jatte – 1884*, 1884–6 (detail of page 45); **page 66** Helen Frankenthaler, *Grey Fireworks*, 1982 (detail of page 78); **page 98** Kay WalkingStick, *Oh, Canada!*, 2018–19 (detail of pages 128–9); **page 130** Frida Kahlo, *The Broken Column*, 1944 (detail of page 152)

Quotations: page 9 John Keats, 'Ode on a Grecian Urn', written May 1819, first published anonymously in *Annals of the Fine Arts*, vol. 4, no. 15, XX (Sherwood, Neely, and Jones, London, 1819), page 639. Hathi Trust Digital Library; **page 37** Email from Kay WalkingStick to the author, 5 November 2021; **page 67** *Boys' Workers Round Table, A Magazine of Applied Ideals in Boycraft*, vol. 3 (Boys' Club Federation, New York, NY, mid-summer 1923), page 3, column 2, without attribution. Hathi Trust Digital Library; **page 97** James Johnson Sweeney, *Marc Chagall* (Museum of Modern Art, New York, NY, in collaboration with The Art Institute of Chicago, Chicago, Il, 1946), page 7; **page 131** Giorgio Vasari, *Le Vite de' più eccellenti pittori, scultori, ed architettori* (Lives of the Most Excellent Painters, Sculptors and Architects) (Second expanded edn; Giunti, Florence, 1568); Introduction to Part Two, page 1, translated by Janetta Rebold Benton